OTHER THAN ITSELF

Writing
Photography

Anita Phillips
Francette Pacteau
John X Berger
Karen Knorr
Leslie Dick
Marie Yates
Olivier Richon
Peter Wollen
Victor Burgin
Yve Lomax

Edited by John X Berger and Olivier Richon

CORNERHOUSE
PUBLICATIONS
MANCHESTER

in association with
Derbyshire College of Higher Education and Camerawork

First published in 1989 by
Cornerhouse Publications
70, Oxford Street
Manchester
M1 5NH

061 228 7621

ISBN 0 948797 35 5

© Cornerhouse Publications, John X Berger, Olivier Richon and the contributors

Design : Christopher Lord
Typesetting : Manchester Free Press
Print : Jackson-Wilson, Leeds

Published in association with Derbyshire College of Higher Education and Camerawork, with assistance from The Arts Council of Great Britain

INTRODUCTION

Other than itself — the expression indicates a conception of photography as a medium of reproduction and representation which refers to things beyond itself: other stories, discourses, images. It proposes an allegorical structure which adulterates the putative purity of the image. The expression is also the minimal definition of allegory: 'something turned into something else ... one text read through another'.[1]

Writing photography: a sub-title which indicates a concern with the relation between word and image, but also an emphasis upon photography as a form of writing, a sign system: writing photography addresses the question of writing *about* photography. Writing about photography poses the question of metalanguage, which tends to have the upper hand: writing 'on' photography, being on top of, above it. Writing photography proposes a detour, displacing our sense of boundaries between theory and practice. The photographic practices included here are theoretical just as the written contributions often read like critical fictions.

In 'Beyond Analogy, the Image'[2], Christian Metz emphasises the hybrid nature of visual signs, arguing that the conception of the image as an autonomous entity is the expression of the ideology of the 'purely visual'. The purely visual would constitute the imaginary plenitude of such an ideology. What can be mapped out instead is a conception of the image as constituted by a system of relations: to the theology of the purely visual a heterology is preferred, where image and language come into play. When thought of as an analogical system of representation, photography runs the risk of being understood as an unmediated representation: an unadulterated transposition of objects in the world onto the photographic surface. Similarly, for those who hastily interpret Pierce's analysis of images, the photograph as an indexical sign emphasises an edenic notion of the visual: the photograph as an imprint of the world, a fossilised referent, a trace of Nature: an aesthetic of the image seemingly devoid of any rhetoric. Analogical and indexical signs necessarily imply a transformation.

An image cannot be understood in terms of its origin only. And if the origin is a fiction, a construction, then the image refers to other images: an intertext, a displacement. The image is characterised by allegory and parody. In this sense, the term analogy may be transformed, leaving behind its naturalist implications. It then becomes 'the demon of analogy' — the expression is from Mallarmé: a chain of associations, displacements and condensations. Analogy ceases to propose a happy marriage between sign and referent, emphasising instead a difference: the image becomes other than itself.

For Schopenhauer, an allegory 'should not be considered as a work of representational art but rather as a hieroglyphic sign'.[3] It is a form of writing, a rebus and cannot be apprehended by a purely visual knowledge. Allegory is to be found within the structure of the work itself as in a particular mode of reading images which stresses interpretation and commentary. The disjunction between what is staged and what is meant is constitutive of an allegorical intent. This disjunction also triggers an allegorical reading, a desire for interpretation, where something is turned into something else. Thus in *The Virtues, The Vices and All the Passions* (Anita Phillips), Vira remarks of visual emblems that 'instead of being easily accessible, as they were meant to be, they seem to produce bafflement. One's left wondering what on earth an olive branch means when set next to a dead rabbit and an open compass.' There is no true or ultimate meaning to the emblem, and no author in charge of such truth: its seduction is to hide rather than to reveal. Allegory is a form of conceit which in Diderot's words, resembles *'un tissu d'hiéroglyphes entassés les uns sur les autres'* [a fabric of hieroglyphs piled one on another][4]. *Office at Night* (Victor Burgin) employs an allegorical structure in its organisation: it is a commentary upon Hopper's painting, as much as a visual analysis of the relation between model and copy. By using similarity and difference,

[1] Craig Owens, 'The Allegorical Impulse', *October 12, 13*, MIT Press 1980.
[2] Christian Metz, 'Beyond Analogy, the Image', *Communications 15*, Le Seuil 1970.
[3] Quoted from Mario Praz, *Studies in Seventeenth-Century Imagery*, Edizioni di Storia e Letteratura 1964.
[4] Ibid.

the ideal model of communication is undermined, the work becoming a fabric of hieroglyphs. The pretended transparency of the photograph and the coded clarity of the pictogram do not provide a relation between signifier and signified. Instead, their juxtaposition provides a relation of signifiers, an ongoing substitutive chain without an originary signified — the demon.

Typography punctuates *The World is a Fabulous Tale* (Yve Lomax): an elliptical primer where letter, word and image are inseparable; an emblem for the death of an empirical referent in the world: 'Gone is the prior reality which stood steadfast and remained independent of the image. Gone is the essence which waited to be discovered behind the front of appearances.' A playful questioning of the precedence of the real over its representation, the text shifts between the academic and the fictional genre and indicates a refusal to write 'on' representation, in the manner of metalanguage. Photography punctuates *The Skull of Charlotte Corday* (Leslie Dick); the photograph of a skull is the signifier which articulates discourses of positivist criminal anthropology, psychoanalysis, history. Charlotte Corday is perhaps best known by David's painting of the dying Marat: the *Ami du Peuple*, in a statuesque pose, with marble-like skin, is shown expiring in his tub, one hand holding the letter that Corday had sent. If Corday's body is excluded from the scene — she is metonymically present via the letter — her skull will later haunt the imaginary of positivist criminology. A trophy, a part detached from the whole, a fascinating relic which might inform the equally fascinating art of portraiture. The trophy also belongs to the art of the bestiary. In *Imprese* (Olivier Richon), exotic animals preserved by taxidermy become signs of Nature as much as elements of an opaque alphabet, a dead language, a Latin. They are preserved in the same manner as typography assumes the body of letters, 'with sharper outlines than the articulation of lips can give them' (Bodoni, *Manuele Tipografico*). The animal is a reminder of Aristotle's classification as much as an actor in charge of the rhetorical illusionism of the photograph. An *impresa* is an imprint, an image and motto which interpret one another. Here the work quotes a seventeenth century tradition of word and image in order to address a fictitious archeology of representation.

Reading the image as a conceit belongs to what Barthes treats as the paradigmatic dimension of the photographic image: 'The still, by instituting a reading that is at once instantaneous and vertical, scorns logical time.'[5] *Fire and Ice* (Peter Wollen) shifts attention from the spatial dimension of the photograph to the temporal, narrative dimension. When applied to photographs, a semantics of time considers captioning and sequencing as constitutive of the narrative structure at work in photography. This emphasis would displace the common opposition between the still and moving image, and complicates the question of the spectator's identification with a narrative form. *Details from Hawthorne* (John X Berger) uses a series of quotations and makes a non-illustrative relation between photograph and text. Both are fragments — visual and narrative fragments which abjure cause and consecution. Edited excerpts from Nathaniel Hawthorne's *Blithedale Romance* accompany photographs of drawing rooms, public monuments and civic institutions. The images are sequenced to articulate relations between characters of the novel in terms of gender and discourse, producing an irony where what is said is not seen and what is seen remains silent.

In *Taking Sides and Drifting Around* (Marie Yates) the fragmented texts and bodies of mass media images are silent and seductive: depth disappears and surface takes over. The surface, the signifier, is the fetish, in the etymological sense: from the adjective *feitiço* in Portuguese, meaning artificial. The fetish implies 'a fabrication, an artefact, a labour of appearances and signs... From the same root *(facio, facticius)* as *feitiço*, comes the Spanish *afeitar*, 'to paint, to adorn, to embellish' and *afeite*, 'preparation, ornamentation, cosmetics'.[6] The artifice of representation articulates a desire for the image. *Beautiful Fragments* (Francette Pacteau) discusses Renaissance poetry concerned with the glorification and inventory of the woman's body. The *blason anatomique* belongs to a process of cultural fetishisation. The oscillation between idealisation and fragmentation can also be represented by the disciplines of painting and anatomy: the imaginary coherence of the idealised, painted representation of the body is the complement of the dissected body of anatomy.

[5] Roland Barthes, 'The Third Meaning', *Image-Music-Text*, Fontana 1977.

[6] Jean Baudrillard, 'Fetishism and Ideology', *For a Critique of the Political Economy of the Sign*, Telos Press 1981.

The anatomical blason would dissect the woman's (mother's) body and reconstitute it by an excess of signs and metaphors. Photography is implicated in a fetishistic form of writing with light and inherits a process of fragmentation and idealisation from Renaissance perspectivist projection.

Photography is not addressed here as a specific practice but as one belonging to the field of representation in general — a rhetoric of the image instead of an aesthetic of the image, inasmuch as rhetoric disregards the idea of autonomy and self-sufficiency. The contributions here are a comment on the photographic activity, a *para-* rather than a *meta*-language. Parody could indeed be called upon to help define the project of *Other Than Itself,* parody as mockery, of course, but more crucially as a doubling of another text. *Connoisseurs* (Karen Knorr) is a parody of received ideas of beauty and taste as well as a homage to the allegorical cult of the ruin. It uses Chiswick House, Osterley House and Dulwich Picture Gallery as historical spaces in which to contextualise certain aesthetic claims. As Linda Hutcheon writes: 'the prefix 'para-' has two meanings, only one of which is usually mentioned — that of 'counter' or 'against'. ...However, 'para-' in Greek can also mean 'beside', and therefore is a suggestion of an accord or intimacy instead of a contrast.' [7] A paralanguage can allow irony as much as repetition and reinterpretation, that is, a transformation of other texts, of other images. It celebrates a form of intertextuality.

John X Berger and Olivier Richon

[7] Linda Hutcheon, *A Theory of Parody,* Methuen 1985.

THE WORLD IS A FABULOUS TALE

Yve Lomax

is for abstraction. And why, you may well ask, should abstraction be placed in that privileged position which the Greek alphabet reserves for the letter A? Why should abstraction star as the first? A voice pipes up from the back of the room: "But it's mental (sic) to put abstraction first. Abstraction doesn't concern *real things*. Real life, that's what comes first. With abstraction there is a withdrawal from worldly things. To say that A is for abstraction is to really upset the apple cart."

Yes, I had thought it elementary, that A is for apple. I had learnt that A, in designating apple, referred to the primary existence of the real thing in the world. The real thing, or *referent* as some might say. To say that the real thing comes before the sign, the abstraction which is A for apple, had seemed perfectly true to me. And now it seems that I have to eat my words and say that this is not so. Has someone, I ask, been telling tales?

is for fiction (and also fable). As a child I was rebuked for telling tales. No matter who had done what, where and when, parents would sternly warn against telling tales. Playmates, moreover, would thrust their faces forward, glare and emit the following ditty: "Tell tale tit, your mother can't knit and your father can't walk with a walking stick."

Once upon a time, Plato, that most Grand Father of Western Philosophy, also warned against telling tales. For Plato, true philosophy did not tell tales, but poetry, on the other hand, could be accused of spinning stories foreign to truth. Plato's line, so I've heard tell, is that true philosophy rises above the charms and double-dealings of rhetoric; it neither tells tales nor practises the art of persuasion. The task of philosophy is to safeguard the truth from tall stories and the fabrications of fiction, which are the source of error, lies and illusion. The gates of Plato's ideal city are shut to those who spin yarns and tell tales: the poet is banished and fiction is relegated to the other side, opposite the truth.

Truth/fiction: a line is drawn and fiction is excluded from entering truth's domain.

Truth/fiction. "Oh no," moans the child, "do I have to hear about binary oppositions again."

"One," the adults reply ignoring the protest, "has to draw the line. Truth is not fiction as A is not B. You have to sort out the difference between the one and the other. It's a matter of sorting out identity and difference."

F is for fiction and I come to the telling of identity and difference. And so the story goes: A is for identity and B is for difference. A is for the one and B is for the other. As A comes first it follows that B comes second. And as B is secondary to A, a line can be drawn between the two; it follows, hence, that B is the opposite of A. On the one side A and on the other side B.

"Oh mother," whispers the child, "will I have to be either A or B, will I have to be either the one or the other."

On the one side A, on the other side B and in the middle, a line. A/B. Whether visible or not, the line which comes in the middle of binary oppositions draws not only a limit separating the one from the other but also a minus line: A *is not* B. The *line in the middle* comes to mark the place of the other with a loss or lack. B becomes the minus, the negative of A. And so the story goes on: difference is the lack of identity, fiction is the negative of truth and abstraction is the minus of reality.

"Oh! Father," exclaims the child, "if I am to be B, how can I be at all."

The animals went into the ark two by two and I may well say that B is for the binary tale where difference is told in terms of two. Yet within this tale of two only one is ever primary. The binary tale proceeds two by two yet for all the two's one *is* (hurrah! hurrah!) whilst the other *is not*. Truth is not fiction, the same is not difference and man is not woman. And so the story goes on. While

the rains may fall for forty days and nights yet still 'as many dichotomies as necessary will be established in order to stick everyone to the wall, to push everyone in a hole...'.[1]

A is the primary one and B's difference is that it lacks A's prior identity: in terms of this logic it is identity which comes *before* whilst difference follows *after.* Truth is anterior whilst fiction is posterior. A is for the ace whilst B is for the buffoon who has no true face. And so it goes: essence comes before appearance as reality comes before image. The sign follows after the thing as abstraction follows on from concrete matter.

Traditionally, truth is to be 'right'. When truth is missing there is 'wrong' and according to this logic, fiction (as the minus of truth) becomes open to the accusation of illusion, falsehood and lies. Yet it seems to me that before we can *tell* the truth we have to *tell* the fiction. Before we can *tell* the same we have to *tell* the difference. Before we can *tell* A we have to *tell* B.

It seems to me, and I make no claim to be an expert on the matter, that if there wasn't B there would never be A. Isn't B necessary for A to present itself as the first, the self-same? It seems to me that B's difference, its 'lack', serves to establish and affirm A's primary identity. In short, B enables A to return as A, the same.

Abracadabra: deny the presence of A and then its presence comes to be affirmed. Or, in other words, affirmation through negation. Perhaps a lack had to be invented, had to be 'fictioned' in order that truth could be affirmed as the primary one.

Affirmation through negation, or in other words: I am given you are not. I am Alpha, the One.

Alpha/beta: Greek thought would have us believe that truth or identity is an undifferentiated whole, the one. Yet perhaps the Greek alphabet knows only too well that the one can be understood only by way of the other, by way of differentiation. Alpha/beta: it is through beta, the second, that alpha can present itself as the first, the one. A may be for apple and B may be for ball but the one is not so well rounded at all. The discovery is not so very new, even Plato knew it: the one is already mediated by the other. Contrary to remaining exterior, fiction is interior to truth as fable is interior to science. Philosophy does not remain untouched by poetry.

A point is made: If you can never tell the truth without telling the fiction, if you demonstrate that the one is always mediated by the other, then it seems that we never come to arrive at the complete and primary one, the *whole* truth. We are, as it were, continually deferred from reaching the one in all its singular glory. The one is impossible to grasp; there is, if you like, an endless postponement.

Abracadabra: demonstrating the impossibility of grasping the one only comes to affirm its power and presence, albeit absent. Although we may never reach the one, the very idea of postponement posits a point even if we are deferred from ever reaching it.

The truth is dead: long live the truth. Oh! the world is a fabulous tale.

'And in fact we are always under the influence of some narrative, things have always been told us already, and we ourselves have already been 'told'.' Jean-François Lyotard

What follows is a *selection* of other texts, other stories and tales, to which this text has reference. I stress the word selection for there are many other texts (written or otherwise) that could be cited.

[1] '...binary machines of social classes, of sexes, man-woman, of ages, child-adult, of races, black-white, of sectors, public-private, of subjectifications, among our kind-not our kind'. Gilles Deleuze quoted from Alice Jardine, *Gynesis: Configurations of Woman and Modernity,* Ithaca and London, Cornell University Press, 1985, p134.

 is for image (in all senses of the word). As a child I was greatly excited at the prospect of my birthday. The night before was invariably sleepless; I would lie awake imagining what the birthday would bring. What was it that I was looking forward to the most? Was it the present I so desperately wanted but wasn't sure that I would receive? Was it the favourite food that I could eat and eat and eat? Was it the cake that was to be baked and decorated with candles and my name? Was it the party where I could play 'postman's knock', a kissing and guessing game. Or, was it the birthday cards which I would receive through the post? (Oh, the thrill of those envelopes which bore the marks of having made a journey.)

On the 18th of December it is my birthday, the anniversary of the day on which I was born. Each year, on the same date, the anniversary returns. 'Many Happy Returns'. As the birthday cards are posted and kisses given again, is it assumed that the recipient is one who has also returned the same? Upon the birthday there is, so I am told, a returning to 'the day of one's birth'. Once upon a time, one day, there was a birth. And is this day returned to as the birth of a *one*? You may well say that such a one provides the birthday with an origin and point of return. In which case I ask the following question: is the image you have of the birthday one behind which there remains a primary and essential one? If you take such a one to be behind the birthday images or signs, all the cakes and candles, kisses and cards, if you assume that it is towards this one that you turn back, then it seems to me that *images* are taken as coming after, as *posterior*.

I have heard it said, often enough to become somewhat of a commonplace, that we live in a world of images. I have heard it said that we live in a world where images are *posted* everywhere.

I is for image, not only those which are photographic or chromatic but images in all senses of the word. And would you say that we live in the Age of the Image? And would you classify this as a *post age*, an age where everything comes after?

In the late 20th century, on planet Earth, we hear of a discovery: nothing solid or substantial stands behind the surface of the image. This discovery, which perhaps is neither so new nor so very extraordinary, finds that we earthlings can no longer be sure of a singular reality which comes before and remains outside of the image, appearance or sign. One of the theories we hear is that a real world is not waiting 'out there' to be reflected, represented or captured by the image. The very idea of an independent reality is thrown into question and things can no longer be proven in quite the same way. Indeed, it has been said that behind the photograph there is no essence — of truth, reality or referent — which provides its origin and point of return. And furthermore, we hear that the countryside which blows an air so fresh and natural beyond the billboards and city signs is itself but another image. One of the stories we hear, one of the theories perhaps we fear, is that the *real world is a fiction*.

 is for the line in the middle and also for long, long ago. "Fadófadó or a long, long time ago, if I were there then I wouldn't be here now; if I were there now and at that time I would have a new story or an old story, or I might have no story at all." And so repeats the Irish story teller before the telling of the tale.

"Nothing solid or substantial stands behind the surface of the image... the real world is a fiction." And what may you make of these lines? What might be your interpretation, your story? Perhaps you have a new story or an old story...

One tale that may be told is that the very idea of some thing coming before and remaining outside of the surface of the image is only an effect of the surface itself. And again, this tale may be put another way, it may be told that it is the second which brings about the impression of the first as the original and primary one. Indeed, it may be told that the anteriority of the first is produced by the posteriority of the second.

From such a story told, the theory may unfold that we live in a *post-world*. We may easily agree

that we live in a world where everything comes *after* before. Indeed, we may easily agree that we live in a world that is without origin. And as this theory unfolds, the story may be told that having nothing before we are left only with fiction and image, only appearance and sign. If the first is only an effect of the second, we end up, so it would seem, with just seconds. And ending up with seconds it would seem that we may as well start by saying that B is for beginning. In the beginning, the image. And taking B for beginning it may then be told that A is for absence. A no longer designates the apple, no longer "refers to the primary existence of the real thing". A great wind blows among the trees and everywhere fruits fall: A is no longer for apple but rather, absence. Yes, the theory may unfold as a tale of loss...

Gone is the referent which came before and was the past of the sign. Gone is the prior reality which stood steadfast and remained independent of the image. Gone is the essence which waited to be discovered whole behind the front of appearances. The singular truth is fallen, anteriority is no more and gone is the unity of the one.

If A is for absence then I may as well say that L is for loss. Hearing that we are left with just images or fictions, just abstractions and signs, it is easy to conclude (once again) that something is missing, something is lacking, something *is not*. Indeed, it is easy to conclude, posthaste, that if there are just surface effects then there is no longer depth. The logic here (once again) is that if there is just abstraction then we are missing concrete reality. Without the presence of that primary and original one all must be inauthentic.

It comes as little surprise to hear the logic that without depth, without an essence beyond, all becomes most flat and superficial. Depth disappears and decoration dances. Without reference to a depth beyond, signs only dance with other signs, images only refer to other images. And I must say that I am not astonished at all to hear the pronouncement that if there are only signs and surface effects then the referent, along with the real world and the documentary photograph, is no longer, is no more, is dead.

It comes as no surprise that within this tale of loss the logic should call for the conclusion that a prior and autonomous real world is no more, that the referent, amongst other things, is dead. The twist in this tale of loss is not just that the logic should call for us to pronounce the loss of the real world, the death of a referent which authoritatively came before, but also that it first requires us to agree that the real world or referent was really 'that' and *only* that.[2] We come to consent to a conception of a one reality as if such a conception were the only one.

Abracadabra: deny the presence of something, say that it is no more, and then we come to affirm its presence, albeit absent. I may deny the referent and say 'the referent does not constitute an autonomous reality at all'.[3] I may say that the referent is only an effect of representation, only an effect of the sign. Yet, glory be, the more the referent's anteriority and authority is denied, and the more this is lamented as a loss, the more forcefully its presence, albeit absent, is affirmed.[4]

The referent is dead: long live the referent. Oh! the world is a fabulous tale.

So, I may well pronounce that the real world no longer comes before the sign. I may well declare that identity comes not before difference. I may well exclaim: no longer, no more! Yet in this tale

[2] 'The curious clarity here is not that this logic then requires us to declare the death of meaning, but it *first* requires us to consent that meaning was really 'that' — and *only* that.' Meaghan Morris, 'Room 101 Or A Few Worst Things In The World' in André Frankovits (ed.), *Seduced and Abandoned: The Baudrillard Scene*, Sydney, Stonemoss Services, 1984, p101. Re-printed in *The Pirate's Fiancée*, London and New York, Verso, 1988, p197.

[3] Jean Baudrillard, *For a Critique of the Political Economy of the Sign*, St Louis, Telos Press 1981, p155.

[4] 'The more resolutely the referent is assailed, the more it seems to affirm its unmistakable presence, albeit in its absence.' Richard Allen, 'Critical Theory and the Paradox of Modernist Discourse', *Screen*, Vol 28 No 2, Spring 1987, p72.

of no longer I come to agree that *before* (perhaps long ago or not so long ago) reality or identity really did come before. No longer yet long ago.

Upon the telling of such a tale we come to feel sure that *before* reality really did come before (the sign, the image...). By way of a tale of loss a tale is told of the way things (really) were. Once, perhaps before the late 20th century, there really was a before which came before the image, fiction or sign. Yet, whilst we may feel sure, we nonetheless come to make this very *before*. Telling tales of an absence, a presence is produced; a past is made that lasts as the way things used to be.

Yet, if I had been there then I wouldn't be here now; if I were there now and at that time I would have a new story or an old story. There is more than just one tale that can be told.

I may well make a before by telling a tale of loss. Yet my tale may be that before (and after) are open to interpretation. "There are no facts," Friedrich would say, "there are only interpretations." Fadófadó or a long, long time ago...

After my very first history lesson at school, I excitedly hurried home to my parents to ask if long ago they had lived in caves and dressed in the skins of wild animals. "Dad.... were you really like that long ago?"

Whatever the story or theory that may be told, how can you or I ever be sure of before and after? Can you or I be sure that the first is former and the second is the latter.

If in the first place, the first requires the second place in order to appear in the first place, if the former is not former unless first there is also the latter, then it seems to me that neither the first nor the second are, strictly speaking, 'in place'. Blurred is the boundary between the two. And to conclude that we live in a world where we end up (or begin) with the 'seconds' — to say that we live in a 'second-hand world' — seems to me highly questionable.

L is for the line in the middle and you may well say that we are being led a merry dance. We are entangled in the midst of a tale, the outcome of which remains undecidable. Try as we may, neither the first nor the second can be put 'in place'. Call out the first and you will find it changed into the second. Call out the second and you will find it changed into the first. Or, as it may be put: 'the player who calls 'identity' will find it immediately changed into difference; and if he calls 'difference', it will be metamorphosed into identity.'[5]

L is for the line in the middle and what you may well ask has happened to this line such that boundaries should be blurred and we be led a merry dance? It seems pertinent to ask if that line has not been wavering, if indeed it is not inclined towards taking turns, dancing around and metamorphosing.

It had appeared that the line in the middle came in between, enabling the one to distinguish itself and an opposition to be settled. The line in the middle appeared to form a sort of medium, the means whereby to establish the difference between the one and the other. Yet with this 'medium' we find that something else also happens: the one comes to be 'mediated' by the other; both become mixed up in the middle. In coming between, the line in the middle ineluctably involves the one with the other. It dances across the two terms and unsettles them both. Just as the difference becomes settled we find that it also becomes unsettled.

Putting this yet another way we may say that the line in the middle marks the threshold of the binary tale. Yet upon entering this tale — in the middle — we find an ambiguity. We find, perhaps not to our surprise, that the two terms are mixed up together such that strictly speaking, both are neither the one nor the other. Neither/nor: we waver between the one and the other, not knowing quite which is which.

"Ding dong merrily on high," the child impishly sings, "it remains undecided as to whether I

[5] Vincent Descombes, 'Originary Delay (Derrida)', *Modern French Philosophy*, Cambridge University Press, 1980, p152.

shall be one or the other. Ding or dong, dong or ding? Perhaps I shall be both but then maybe I shall be neither."

In mid-flow the binary tale turns into a tale of oscillation.[6] And in this tale which may go on and on, we remain undecided as to whether we are here or there. We are somewhere unlocatable; somewhere between.

"There is the dance," she quietly remarks, "but where to locate the place of the dancer."

L is for the line in the middle and it seems that we have a line (and a tale) which is not in the least straightforward. In coming between we find that the line in the middle oscillates between settling an opposition and unsettling that very opposition. You may well say that the line in the middle marks both the difference between the one and the other and the abolition of that very difference.[7]

"Yes," she remarks with a gentle smile upon her face, "the line in the middle is oblique; there never will be just one story that can be told."

 is for middles and many things. M is for the many stories and meanings that may be told. That we are neither one thing nor the other, that we are neither inside nor outside but somewhere between, may soon become a tale of numbing neutralisation. Indeed, the story may be told that indifference infects the land. All too quickly the line in the middle turns the land to sand and we become lost to the perpetual shifting of the bleached white desert. Unable to fix definite places, unable to make firm and final distinctions, we wander a desert of indifference with blank expression. We no longer know for certain who we are or where we are going and, what's more, we don't give a toss.[8]

Rather than turning all to desert sand, the unsettling of binary difference may turn into a tale of implosion. The story here is that the line in the middle mixes up the one and other to such an extent that the very difference between the two inwardly collapses. The difference implodes under the sheer weight of wavering between the one and the other.[9] That we are neither/nor turns

[6] Perhaps what is happening here is that the binary tale turns into a Derridean tale of oscillation and undecidability — 'both one and the other' and 'neither one nor the other'. Of course it would be foolish of me to suggest that Jacques Derrida, contemporary French philosopher, tells but one tale; yet, in terms of 'deconstructing the binary oppositions of Western thought', Derrida's strategy maybe summed up by the words oscillation and undecidable. Derrida takes his time to sniff out undecidable words, terms whose double meaning cannot be mastered or pinned down. For the sake of brevity, I shall list but a few: supplement, difference, pharmakon, milieu, middle voice, hymen. (See note 7 for more on the word hymen.)

[7] 'In "The Double Session' (...) Derrida elaborates on one of his most powerful deconstructive levers and completes this genderization of writing — as the place where male and female remain undecidable — as feminine. Here, the undecidable, like the *pharmakon* in Plato [not just poison nor just cure yet both poison and also cure] or the *supplement* in Rousseau, becomes, in fiction, (Mallarmé's) 'hymen'. (...) For Derrida, the hymen is the 'absolute' in undecidability: there is hymen (virginity) where there is no hymen (marriage or copulation); there is no hymen (virginity) when there is hymen (copulation or marriage).' Alice Jardine, op cit, pp189-190.

'The hymen is both difference (between the interior and exterior of the virgin (...)) and the abolition of difference.' Vincent Descombes, op cit, p152.

[8] 'All that remains is the fascination for arid and indifferent forms.' Jean Baudrillard, 'On Nihilism', *Simulacres et Simulation*, Paris, Editions Galilée, 1981. '...why are the deserts so fascinating? It is because you are delivered from all depth there — a brilliant, mobile, superficial neutrality, a challenge to meaning and profundity, a challenge to nature and culture, an outer hyperspace, with no origin, no reference-points.' Jean Baudrillard, 'Desert for Ever', *America*, New York and London, Verso, 1988, pp 123-124.

[9] 'Strictly speaking this is what implosion signifies: the absorption of one pole into another, the short-circuit between poles of every differential system of meaning, the effacement of terms and of distinct opposi-

out to be a most disastrous plight, 'the worst thing in the world'.[10] As the binary code implodes we are sucked into a black hole and deprived of a guiding light; we lose sight of all meaning and feel hopelessly forsaken. To see is no longer to be and to know is no longer to awaken.

There is yet another story which I have heard told, a tale which is somewhat more lengthy. In unsettling the one and the other, such that we become unsure which is 'either' and which is 'or', the line in the middle begins to gather momentum. The story here is that the line in the middle picks up speed and whilst so doing turns into a stream. In this tale a stream flows and gnaws away at its two banks; it picks up speed in the middle and carries away the one and the other. Here we have a stream — a line and a middle — which is without beginning or end.[11]

Suddenly we find ourselves moving in the very middle — midstream — of things, no longer attempting to grasp the banks of binary difference. And here, in the middle of this tale, we find also that 'things' themselves rapidly begin to change. The stream that flows becomes a plant that grows from the middle: 'Things which occur to me present themselves not from the root up but rather from somewhere about their middle. Try then to seize a blade of grass and hold fast to it when it begins to grow only from the middle.'[12]

In this world of a burgeoning middle, we find, so I hear, that any single thing (and this includes you and me) is involved with, in the middle of, many other things. Any 'singularity' is also a 'multiplicity' — to use the favoured terms. The relation between the one and the many ceases to be that of an opposition; the issue of difference has taken quite a different slant. That we may speak of a singularity is not a matter of locating an inside and outside, a text and a context, a center and circumference. For in this tale we are in the world, indeed worlds, of networks and nodal points. And with this sort of *milieu* we shall never arrive at a thing-in-itself which has intrinsic properties independent of its environment. Things turn out to be inter-connections between things which in turn are inter-connections between other things.[13] Yet these 'lines' (in the middle), these inter-connections, shall never lead us to an all-knowing Theory of Everything. There is always an element of uncertainty; these lines and connections rarely proceed in a straight-forward manner. Any one connection may produce a multiplicity of effects — a multiplicity of other connections, other lines. And here we require prudence: how will one line affect others? In this tale emphasis is put upon considering others; as the philosopher might say, ethics is given priority over epistemology and ontology.

tions... .' Jean Baudrillard, 'Implosion of Meaning', *In The Shadow of The Silent Majorities*, New York, Semiotext(e) Foreign Agents Series, 1983, p102.

[10] For a wonderful analysis of Jean Baudrillard's ('worst') tales and tall stories see Meaghan Morris, op cit.

[11] 'The middle is not at all average — far from it — but the area where things take on speed. *Between* things does not designate a localizable relation going from one to the other and reciprocally, but a perpendicular direction, a transversal movement carrying away the one *and* the other, a stream without beginning or end, gnawing away at its two banks and picking up speed in the middle.' Deleuze and Guattari, 'Rhizome', *On the Line*, New York, Semiotext(e) Foreign Agents Series, 1983, p58.

[12] Franz Kafka, Diaries 1910-1923 quoted from ibid, pp52-53.

[13] 'In itself the rhizome has very diverse forms, from its surface extensions which ramify in all directions to its concretations into bulbs and tubers. (...) We are well aware that no one will be convinced if we do not enumerate certain approximate characteristics of the rhizome. 1 and 2 — Principles of connection and heterogeneity: any point on a rhizome can be connected with any other, and must be. This is very different from a tree or root, which fixes a point and thus an order. The linguistic tree according to Chomsky still begins at a point S and proceeds by dichotomy. In a rhizome, on the contrary, each feature does not necessarily refer to a linguistic feature: semiotic chains of every kind are connected in it according to very diverse modes of encoding, chains that are biological, political, economic, etc., and that put into play not only regimes of different signs, but also different states of affairs. In effect (...) no radical separation can be established between regimes of signs and their object.' ibid, pp10-11.

In this tale where we are always entering things in mid-flow, I hear that no one thing can assume the determining part, the cause or origin. Whilst there are determinations, things affecting each other, who ever claims a singular cause, surely invites derision. For in this world it turns out that any such cause is already effected by other things.

And in this tale which sings not the praises of singular causes, I hear that interpretation can never be brought to an end. Knowledge is not so much a proclamation of certainty — I know that I know! — but more, as I have heard also from Hebraic tradition, an understanding that any interpretation is provisional and open to alteration and re-interpretation. Any theory, any story, or indeed truth, is that which could always be otherwise. That truth could be otherwise brings into play that element of uncertainty and, moreover, throws into question the *falsity* of other interpretations.

M is for middles and many things. M is for the many tales and meanings that maybe told. Blackholes and deserts, streams and fluid things — Oh, the world is a fabulous tale.

''So,'' the child remarks with zest, ''maybe I shan't be speaking of a loss of an independent real world or telling tales of the death of the referent. Perhaps I shall say that the existence of an independent real world is one story amongst others. As for apples and images — well, I might just tell the tale that with both 'things' and 'signs' (both nature and culture) we always start in the middle and that in so doing the question of the referent, its absence or presence, becomes more a question of connections, of effects and affects. As the philosopher may indeed say, more a question of ethics than of epistemology and ontology.''

To which the listener might add: more a question of ecology than 'representation'.

OFFICE AT NIGHT

Victor Burgin

*O*ffice at Night, 1940, may be read as an expression of the general problem of the organisation of Desire within the Law, couched in terms of the particular problem of the organisation of sexuality within capitalism — symptomatically represented by those (dis)contents filed under 'working late at the office'.

F or Renaissance art theory, Hopper's painting would be both *tableau* and *hieroglyph* — both the *mise en scène* of a moment of narrative crisis, and the cryptic inscription of a general truth. Psychoanalytic theory finds this same duality in the formation of the unconscious fantasy.

F reud, in his 1911 essay, 'A child is being beaten', describes a sequence of fantasy identifications in which spectator and participant, aggressor and aggressed, perpetually exchange places in a drama which, like an image, neither changes nor remains the same. A drama whose purpose is to stage the desire it would deny.

I n Hopper's painting, 'secretary' and 'boss' are at once the image of a particular bureaucratic dyad, and an iconogram serving to represent all such relations of subordination in the (re)production of wealth. The inscription of the power relation across the gender divide respects a patriarchal polarity.

C onstantly threatening the productive order of the workplace is that erotic supplement to the biological reproduction of the workforce which cannot be contained within the family. A state of crisis ensues to which this painting, hieroglyph of patriarchy, offers a solution.

E gyptian sages, observed Plotinus, in a passage translated in the Renaissance by Ficino, ''.... drew pictures and carved one picture for each thing... each picture was a kind of understanding, and wisdom and substance given all at once, and not discursive reasoning and deliberation''.

A body twisted, impossibly, so that both breasts and buttocks are turned towards us. A body ostensibly clad in a modest dress, but a dress which clings and stretches like a costume of latex rubber. She is here for no other reason than to be seen. Her intelligence is not investigative, merely inquisitive. The cabinet she opens is a Pandora's box.

T he elaborately constructed alibi pivots on a disavowal of voyeurism: 'I (male spectator) know very well that I am looking at the body of the woman, but nevertheless I (imaged man) am engrossed in my work.' If anything 'happens', it will not be *his* fault. The painting both offers itself in his defence, like a photograph in a court of law, and functions as the very allegory of Instinct and Reason.

N eurath's ambition for the Isotype (International System Of Typographic Picture Education), 1936, was that it would become a universally unambiguous picture language. Heir to the dream of 'pure vision', it expresses the desire to know in a simple act of *seeing*.

I t happens that Neurath's search for the unambiguous image was taking place in Vienna at the same time as Freud's researches into the irresolvable ambivalences of the psychic processes. With the onset of Nazism, both took refuge in England. For a while, both lived in the same London suburb, neither known to the other.

G ail Levin writes that the office equipment and furnishings seen in Hopper's 1940 painting are derived from his catalogue illustrations of around 1910, albeit the dress worn by the woman in the picture clearly belongs to the same period as the painting. (Time, Freud remarked, does not exist in the unconscious).

H opper painted *Office at Night* in the same year I was conceived. As a small child I was given a book which contained a picture of a businessman in a suburban street; he is unaware of the brutal and threatening Neanderthals who are shown crouched in a ditch by the road, waiting for night. I understood nothing of this image, and accepted it totally.

T he Isotype archive is currently housed at Reading University, which has a Department of Typography and Graphic Communication. One of the legacies of the isotype movement is a problem which successive generations of students have attempted to solve: design a pictogram which says neither 'man' nor 'woman' but simply *person*.

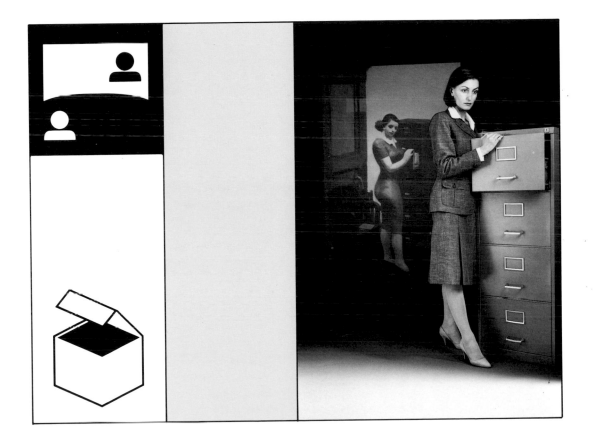

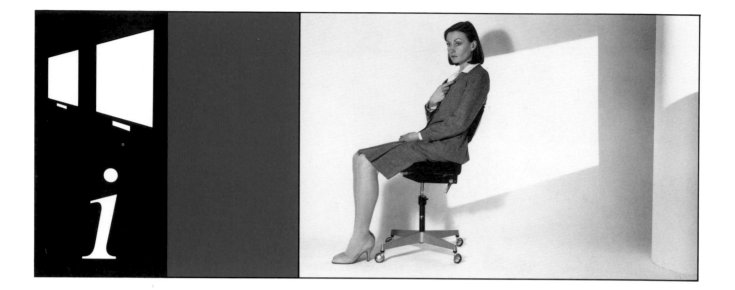

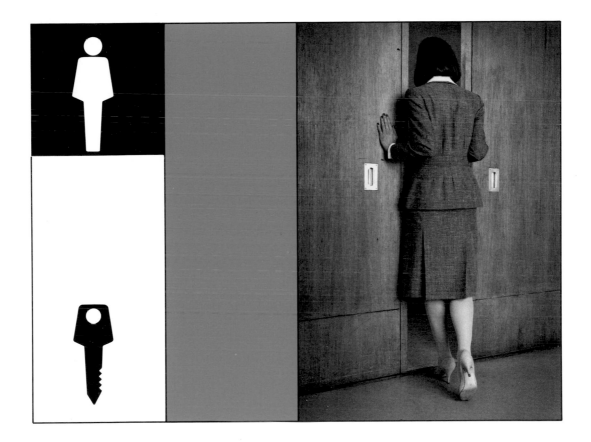

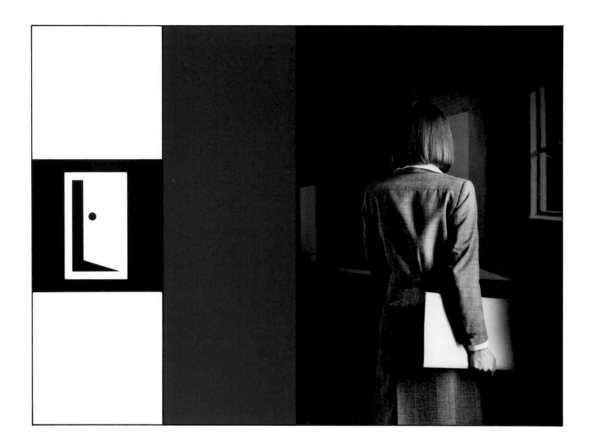

TAKING SIDES AND DRIFTING AROUND

Marie Yates

SPACES, MORE OR LESS AMO
WE SEE PERHAPS, TWO BOD
RELATION TO EACH OTHER.
BREAKING UP THAT SPECIAL U
IMAGE, AND THE METAPHYSIC
PIECES. DO THESE FRAGMEI
NARRATIVE SPACES, POSITIOI
CONVERSATION, THE QUARRE
A FRAGMENT INTO A WHOLE C
IDENTIFY WITH IT?
OR DO WE NOT MOVE TOWAR
PROXIMITIES OF THE PARTIAL
LEFT, BUT HOVERING BETWE
TWO POSITIONS, THE TWO CH
NESS AND DISTANCE?
FIGURES OF SPEECH OR POSIT
WHICH TO SPEAK. ARE THERE
QUITE COINCIDE, AND ARE NEV
WOMEN OR BY MEN.

OUS

S, CUT AND FRAMED, IN SOM

THE CUTS AND FRAMES AR

TY OF BOTH THE BODY AND TH

AL INTEGRITY SEEMS TO LIE I

TS REMIND US OF PARTICULA

S OR FIGURES OF SPEECH? TH

, THE RETORT? CAN WE MAK

ARACTER AGAIN, IN ORDER T

S THE SPACE BETWEEN: TH

OSITIONS, NEITHER RIGHT NO

N THE IMPOSSIBILITY OF TH

ICES, IN THIS PLAY OF CLOSE

ONS OF POWER : PLACES FRO

NLY TWO? TWO, WHICH NEVE

R QUITE INHABITED, EITHER B

IMPRESE

Olivier Richon

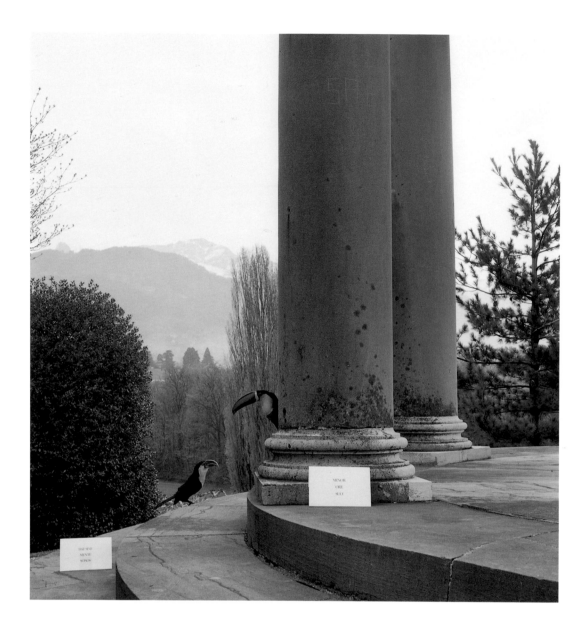

WITHOUT KNOWING WHAT THEY SAY THEY SAY MANY THINGS

A LARGE BEAK UPON A SMALL BODY

IT DOES NOT FLY TOO HIGH

YOUR TRICKS PAIN ME

THE TEARS OF CONCUPISCENCE

AS THEY WORK ITS MOUTH WATERS

THEY BORROW YET DO NOT RENDER
BY REPEATING THEY AUGMENT THEIR WISDOM

ITS SOFT BELLY BETRAYS IT

FROM NEAR AND FROM AFAR

THE VIRTUES, THE VICES AND ALL THE PASSIONS

Anita Phillips

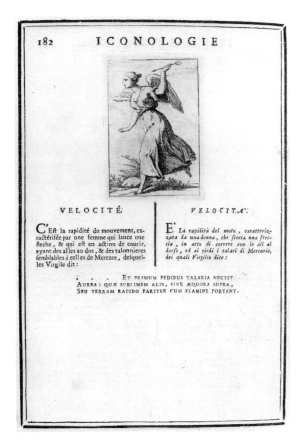

VELOCITÉ.

C'Eſt la rapidité du mouvement, ca-
ractériſée par une femme qui lance une
fleche , & qui eſt en action de courir,
ayant des aîles au dos , & des talonnieres
ſemblables à celles de Mercure , deſquel-
les Virgile dit :

VELOCITA'.

E' La rapidità del moto , caratteriz-
zata da una donna , che ſcocca una frec-
cia , in atto di correre con le ali al
dorſo , ed ai piedi i talari di Mercurio,
dei quali Virgilio dice :

> . . . ET PRIMUM PEDIBUS TALARIA NECTIT
> AUREA : QUÆ SUBLIMEM ALIS , SIVE ÆQUORA SUPRA ,
> SEU TERRAM RAPIDO PARITER CUM FLAMINE PORTANT.

Velocity

This is rapidity of movement, characterised by a woman who throws an
arrow, and is in the action of running, having wings at her back and winged
feet similar to those of Mercury.

Vira was driving an old car, a black Citroën, belonging to her friend Dora. Eyes flickering in the mirror, checking the traffic behind. She turned the steering wheel and moved out onto the main road. Romantic music, a Brahms piano concerto, played very loud.

She was driving this old car along a road which cut the open country. For a long time there was nothing but the feeling of moving forward, without the landscape changing.

The landscape remained the same.

The music continued.

The car moved forward.

This feeling lasted for some time. Then, with a click, the tape switched off. Vira didn't take out the tape and insert another. She let the sound of the engine and the air rushing past the car take the place of Brahms.

The landscape remained the same.

The car moved forward.

The car in front of Vira's, an ancient British make, unaccountably swerved onto the embankment and braked to a halt. Vira braked magnificently to avoid its tail. The seat-belt saved her from a dive through the windscreen. Her eyes opened wide and then closed completely. Luckily, there was nothing behind. She sat still.

A hedgehog had been granted an extended lease of life. It crept across the road, already an old hedgehog, a bit out of breath and puzzled in its mind.

The man from the car in front came over to Vira and apologised for swerving in such a dangerous way. Vira opened her eyes to look at him. She didn't open her pale lips. As a child I was often car-sick.

— I am sorry. I suppose I'm sentimental. I can't bear to see the squashed ones. You don't share my feeling?

Vira found that in an emergency, her fingers could unfasten the seat-belt — something miraculous, like God's grace; and that she had just the strength to stretch over to the passenger door, push it open, lean over and abandon herself to an attack of vomiting, half-kneeling and half-crouching on the seats.

Gradually the convulsions of anti-peristalsis changed into a fit of sobbing which made her sound like a small, sad, chained-up dog. She struggled upright and grabbed for the tissues to swab her face, which had a dismal, shattered look.

The man was now sitting in the driving seat, looking anxious and holding a bottle of mineral water.

— I thought you might like some of this. To take the bad taste away.

She rinsed her mouth with the water and spat it out in the same direction as the vomit, then closed the door. She drank some.

— You can keep the bottle.

— Thank you, said Vira ironically. He didn't seem to notice the irony.

— I feel marginally better, she added.

— Good. I'm terribly sorry.

Actually, I still feel awful.

— Perhaps you'd better just rest here for a while until you feel better.

— Yes. You go on, though. I'll be all right in a minute.

— Don't worry, I'm not in a hurry.

Vira and the man sat in silence for some time. Occasionally she sipped from the bottle. In this way, the chemical constitution of her insides gradually returned to normal.

— I bet you prefer animals to humans, don't you? she said with a return of strength. Later, when she found out that the man's name was Angel, it seemed to have been appropriate to have recognised something not quite human about him, despite his voice, teeth, hair and other superficial human attributes. But at this point I had no idea that I would ever meet him again.

— That depends, he replied as if the question did not interest him.

He did not seem at all the sort of person that Vira would ever meet again. He wore a Fair Isle sweater and had no particular accent.

— Well, I'm all right except for a blotchy face, said Vira. She then started to cry again. Why was it that I started to cry again? She did this because she liked to do certain things more than once. She could enjoy the second time as she could not have enjoyed the first.

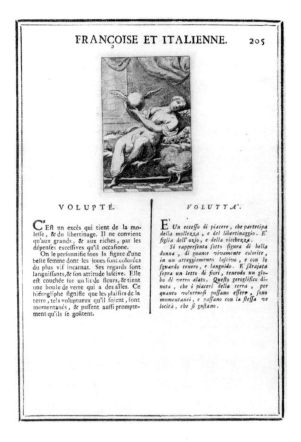

VOLUPTÉ.

C'Eſt un excès qui tient de la mo-
leſſe, & du libertinage. Il ne convient
qu'aux grands, & aux riches, par les
dépenſes exceſſives qu'il occaſione.
 On le perſonnifie ſous la figure d'une
belle femme dont les joues ſont colorées
du plus vif incarnat. Ses regards ſont
languiſſants,& ſon attitude laſcive. Elle
eſt couchée ſur un lit de fleurs,& tient
une boule de verre qui a des aîles. Ce
hiérogliphe ſignifie que les plaiſirs de la
terre, tels voluptueux qu'il ſoient, ſont
momentanés, & paſſent auſſi prompte-
ment qu'ils ſe goûtent.

VOLUTTA'.

E' Un ecceſſo di piacere, che partecipa
della mollezza, e del libertinaggio. E'
figlia dell' ozio, e della ricchezza.
 Si rappreſenta ſotto figura di bella
donna, di guance vivamente colorite,
in un atteggiamento laſcivo, e con lo
ſguardo tenero, e languido. E' ſdrajata
ſopra un letto di fiori, tenendo un glo-
bo di vetro alato. Queſto geroglifico di-
nota, che i piaceri della terra, per
quanto voluttuoſi poſſano eſſere, ſono
momentanei, e paſſano con la ſteſſa ve-
locità, che ſi guſtano.

Sensual Pleasure

This is an excess which runs to softness and licentiousness. It applies only
to the great and the rich, through their excessive expenditure.

It is personified by the figure of a beautiful woman whose cheeks are col-
oured and brightest rose pink. She has a languishing look and a lascivious
pose. She lies on a bed of flowers and holds a glass sphere which has wings.
This hieroglyph signifies that earthly pleasures, however delightful, are tran-
sient and pass as soon as they are tasted.

— The heat in here....

— Would you like to sit down? he asked.

— No. But I think I shall leave, soon.

— I shall be going soon, myself.

— Are you tired?

— No, I'm not tired.

I laughed quietly. He did not smile, refusing the dullness of quick collusion, prolonging the game. I began to feel a sense of urgency. Perhaps that is what he wants. I want to move towards or away from him. I was terrified that I was mistaken about my interpretation of his words and gestures. But I was confident of not showing my terror, or my interpretation.

— I shall telephone for a taxi.

Instead of going to the telephone, I headed for the bathroom. The first thing I did was to look at myself in the mirror. My face was flushed and my eyes very bright, transparently lustful and eager. I splashed my face with cold water and dabbed it with one of Dora's towels. I combed my hair and adjusted my clothing. I made a decision.

— Did you find a taxi?

— No.

I looked straight at him, my face heating again on entering the room.

— That's difficult, he said slowly.

— Not really.

Now is the difficult part. I waited for a moment, but he didn't speak.

— I can borrow one of Dora's cars, I said.

— Or I could give you a lift in mine, he said finally, looking away at the woman in blue. Then he looked back at me and smiled slightly.

— I'm going now.

He drove silently along the river bank, where homeless men live, past the mediterranean-style restaurant terraces and the old, still riverboats.

— I haven't asked you your address.

— That's true.

The speed of movement, like the smooth flexing of a man's arm.

We entered the deserted area at the east of the city, the docklands. Unused now, and all along the docks loomed the machinery of long-abandoned cranes. He stopped the car and we got out. I walked to the water: it looks greasy, heavy. A rope lay coiled nearby. Pieces of rusted metal open to the rain, curious relics gradually reducing to their mineral components. A Victorian brick warehouse behind.

Fell leaned against the car, watching me. I walked back towards him, holding my mouth still. As I came close I looked away, at the warehouse. He made a sudden movement, and my handbag dropped onto the ground, spilling open. I bent forward towards it. Fell gripped me by my arms, pulled me towards him. Off balance, I shifted and fell sideways onto the ground, he falling with me and with all his weight. Winded, I twisted and turned and sat up, knees folded to my chest. We froze, staring at each other. I can feel redness coming up from my body. There is a smear of blood on his mouth.

He leaned his head back against the car, a little to one side. I moved forward until my face touched his. I tasted the red tepid saltiness of his gums, the smooth inside of his cheeks, the hard teeth. Our tongues locked and withdrew, probed and reconnoitred, silently. I can smell the oil and petrol of the car. The grit lying on the ground scrapes my legs.

His skin is softer than a man's should be.... I don't know why I should be surprised that there is no pain...

Neither of us made a sound. His face lost all trace of expression.

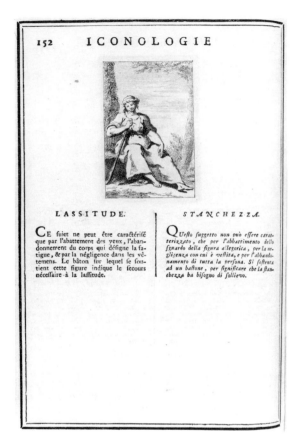

LASSITUDE.

STANCHEZZA.

CE suiet ne peut être caractérisé que par l'abattement des yeux, l'abandonnement du corps qui désigne la fatigue, & par la négligence dans les vêtemens. Le bâton sur lequel se soutient cette figure indique le secours nécessaire à la lassitude.

Questo suggetto non può essere caratterizzato, che per l'abbattimento dello sguardo della figura allegorica, per la negligenza con cui è vestita, e per l'abbandonamento di tutta la persona. Si sostenta ad un bastone, per significare che la stanchezza ha bisogno di sollievo.

Lassitude

This subject can only be characterised by the eyes falling closed, the laxity of the body which shows fatigue, and by the slovenliness of the clothing. The stick with which the figure is supported indicates the assistance needed by lassitude.

Vira lay on the sofa, prone and listless, her mental activity reduced to a minimum. When this happened, she became aware of the physical phenomena which surrounded her: the rain dripping unsteadily from an unfixed gutter-pipe; the sound of cars driving on wet tyres; the trees outside rustling. The reality of her environment impinged on her consciousness at such times: normally, she was hardly aware of it.

Nothing is ever good or wholesome. I wish I were someone else, somewhere else, not here and now and myself.

Occasionally, Vira flattered herself that she resembled slightly Anna Karina in 'Vivre Sa Vie', a film from the sixties about a glamourous prostitute who ends up murdered by gangsters. But at times like this Vira was completely aware that she didn't have the slightest resemblance to Anna Karina.

Rain was dripping from the broken guttering. Vira swore to herself, trying to work up angry feelings. She sat up for a moment. But she immediately regretted the visual minimalism of the bare, white ceiling, and slipped back into a lying position.

The telephone rang. Vira picked up the receiver, listened for a moment, put it down again, and then unplugged it from the wall. She slipped back into a lizard-like stillness. Her eyes flickered at noises from the street. Several hours passed in this way.

While she lay looking up at the ceiling, the price of U.S. dollars on the international money market changed minute by minute. International money dealers talked on several telephones at once in the money capitals of the world, buying and selling denominations. Several thousand babies were delivered and several thousand people met their death, peaceful or otherwise, during the hours of Vira's inertia, and the earth spun on its axis and continued its unending circling of the sun.

The earth spun on its axis.

Fell dozed in a hotel room, alone. The walls of the large room were painted white with a touch of grey. It overlooked, through a large window, a sumptuous bay whose deep blue waters gleamed with the reflected neon lights of hotel and restaurant signs, car headlights and street lamps.

He was lying with a thin sweat over his face, fully clothed, clumsily, in his dark businessman's suit and white shirt. His arms were crooked at each side of his face, as if to protect it from injury as he slept. Dream images — a golden casket filled with tiny snakes; a tunnel under the earth; a horse rearing in fright, bearing its big menacing teeth — came to his brain without forming a proper narrative, insubstantial, half-grasped. He was dimly frustrated by this, by being neither quite asleep nor awake.

He stirred, then turned over onto his other side, and the motion of turning, or the cool sheet, unwarmed by body heat, which met his cheek, now caused a further stirring and a rousing of consciousness. He turned on his back, pushing out his legs in a sudden gesture, eyes squeezing open to two slits, then further, then blinking as his hands rubbed his face and pushed away the strands of hair which had fallen forward. He struggled to sit up, his legs over the edge of the bed, stayed like that for a moment, hands in hair, in a gesture which could be interpreted as despair, but was not, then got up and went to the bathroom.

The mirror told him that he needed a shave and that there were pink creases in his face from sleep.

He took off the suit and stood under the shower, without drawing the shower curtain. The coolness of the water, which he let flow over him effortlessly, for minute after minute, calmed the race of alcohol in his blood. Wearily he rubbed soap into armpits and desultorily washed. As he stepped out of the shower, wrapped himself in the hotel's towel, stood dripping on the bathmat, the confusion of sleep and drink gave way to a sense of calm dereliction.

He shaved and dressed in a lighter suit, and as he combed his hair, the telephone rang. He picked up the receiver, listened, said, "Fine — I'll be down in half an hour — ", returned it to the hook and took one last glance at the mirror, to straighten his tie.

Then he made his way down to the harbour. The others were waiting for him.

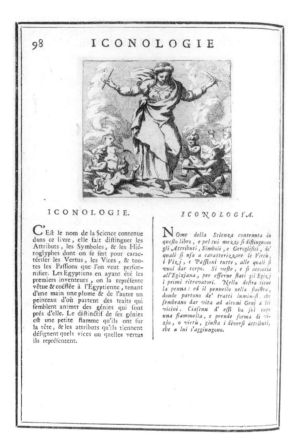

ICONOLOGIE.

C'Eſt le nom de la Science contenue dans ce livre, elle fait diſtinguer les Attributs, les Symboles, & les Hiéroglyphes dont on ſe ſert pour caractériſer les Vertus, les Vices, & toutes les Paſſions que l'on veut perſonnifier. Les Egyptiens en ayant été les premiers inventeurs, on la repréſente vêtue & coëffée à l'Egyptienne, tenant d'une main une plume & de l'autre un peinceau d'où partent des traits qui ſemblent animer des génies qui ſont près d'elle. Le diſtinctif de ſes génies eſt une petite flamme qu'ils ont ſur la tête, & les attributs qu'ils tiennent déſignent quels vices ou quelles vertus ils repréſentent.

ICONOLOGIA.

NOme della Scienza contenuta in queſto libro, e pel cui mezzo ſi diſtinguono gli Attributi, Simboli, e Geroglifici, de' quali ſi uſa a caratterizzare le Virtù, i Vizj, e Paſſioni tutte, alle quali ſi vuol dar corpo. Si veſte, e ſi acconcia all'Egiziana, per eſſerne ſtati gli Egizj i primi ritrovatori. Nella deſtra tiene la penna: ed il pennello nella ſiniſtra, donde partono de' tratti luminoſi, che ſembrano dar vita ad alcuni Genj a lei vicini. Ciaſcun d'eſſi ha ſul capo una fiammetta, e prende forma di vizio, o virtù, giuſta i diverſi attributi, che a lui s'aggiungono.

Iconology

This is the name of the Science contained in this book, which is able to distinguish the attributes, the symbols and the hieroglyphs that are used to characterise the Virtues, the Vices and all the Passions one wants to personify. Because the Egyptians were the first inventors of it, Iconology is shown as a woman with clothing and hair in the Egyptian style, holding a pen in one hand and in the other a paintbrush out of which come rays which seem to animate the spirits which are near to her. What marks these spirits is a small flame on their heads, and the attributes they hold designate which vices or virtues they represent.

Angel called on Vira to collect the typed translations of the texts from the book he had given her.

Vira had been intrigued by the unusual book, but also a little baffled, and irritated. She asked him to explain something about it.

Angel: The emblems are concepts translated into images. They were meant to be completely conventional, so that anyone with any education could understand them.

Vira: I suppose that everyone had to be able to read back from the visual to the linguistic —

Angel: Well, there was always a text underneath so that wasn't too difficult.

Vira: But the emblem had to rely on the received notion of any concept it represented — a consensus definition. So it was like an early attempt to impose certain ways of thinking.

Angel: I'm not sure about that. The main basis of the whole thing was metaphor. Abstract concepts have always been difficult to grasp, and metaphors were used to make them easier to understand. Many of these metaphors were drawn from the realm of sight — "the darkness of ignorance" and so on. So it wasn't really so surprising that finally someone would come along and try to make a system of realised visual emblems representing such concepts.

Vira: But this system had to exclude other metaphors, I suppose, which might have existed or come into being to try to make other conceptualisations of things like friendship, death, and so on.

Angel: That's not what Ripa and his followers, including Boudard, thought. Ripa, the first one to make a book like this of emblems, was an amateur Aristotelian. Artistotle thought that all words were names of things or people, language was literal and offered a total inventory of reality. So that metaphor wasn't a means of conceptualising, but simply an enjoyable form which could always, ultimately, be dispensed with. Aristotle worked by thinking about the qualities and properties of concepts and thus defining them.

Ripa followed Aristotle by looking for material objects which shared the same properties as the concept, then illustrating them. Take the concept 'Fortune'', for instance. Its property is that it can't be grasped, it doesn't stay in one place, with one person, but constantly moves on. Ripa would illustrate Fortune by a wheel, which also moves constantly.

Vira: But isn't a metaphor something which creates meaning, rather than illustrating it? And in any case, the translation of a linguistic metaphor into a visual emblem is fraught with dangers. Looking at these emblems, it's not at all obvious, without the text at any rate, to what they refer. Instead of being easily accessible, as they were meant to be, they seem to produce bafflement. One's left wondering what on earth an olive branch means when set next to a dead rabbit and an open compass.

Angel: I don't remember that one —

Vira: I was only making it up, but do you see what I mean? Perhaps all it comes down to is that Aristotle was the first victim of a passion for classification and systematisation. He first practised on animals, didn't he?

Angel: Yes. The basis of Aristotelian definition was the classification and subdivision of the animal kingdom.

Vira: And wasn't he the one to call man the 'rational animal'?

Angel: Mm. If you're really interested, I could....

Vira: I just thought what an odd thing, because animals are dumb, and can't let us into their perceptions, if they have any, and so we can't really know anything about them, ultimately, we couldn't know the most important things. Which seems a very odd basis for the origins of logic and rationalism, don't you think?

Angel: Well, I don't quite see.... I don't suppose that it matters very much to a vole that it's general-

ly known as a vole and not a mole, or a caterpillar, or for that matter —

Vira: A hedgehog?

Angel: As you say. But to come back to the emblems, for me the thing I like about them, I do like them very much, is that they are not quite as straightforward as they try to claim to be. Humans with wings on their shoulders or feet, or both; people with animals or bizarre instruments perched upon their head or held in the hand; very strange.

Vira: That's true.

Angel: They remind me of dream-images, condensed and displaced from their original meaning, and which need the key of language to be understood. These hybrid compositions, almost all menacing or disquieting, don't seem to either deny or reflect our waking perceptions, but to rearrange them in a way which is supposed to be systematic, but suggests more of the distortion and perversity of the unconcious.

Vira: I didn't suspect you of these kinds of ideas, Angel.

Angel: It's as if the moment of enforcing meanings brings back the most ambiguous things to the surface of the image, the most ambivalent things. It's as you said about Aristotle: a system for defining what ultimately can never be understood.

Vira: Angel, I am not quite sure what you mean.

Angel: Well, sometimes, someone whose job it is to organise and systematise things, like me, who works in a museum, likes to think that some things always escape, even that everything always escapes.

Vira: That reminds me of when I was a little girl: I used to think that my toys came awake at night and danced around. But I never saw them, although I always wanted to.

Angel: It never disturbed your faith when every morning the toys would be back in the exact same position in which you had put them to bed the previous night?

Vira: No. That didn't worry me at all.

BEAUTIFUL FRAGMENTS

Francette Pacteau

I

In her 1984 essay 'On the Eve of the Future'[1], Annette Michelson locates the model for Villiers de l'Isle-Adam's description of the beautiful Alicia in his 1889 novel *L 'Eve Future*, in high Renaissance erotic art, and more specifically in the literary as well as pictorial productions of the School of Fontainebleau under Francois I. This she does by way of a reference to the double portrait of Gabrielle d'Estrées and the Duchesse de Villars in their bath executed in 1594. Michelson proposes two readings of the portriat: in accordance with the iconographer, she interprets the Duchess's gesture of encircling the nipple of her sister's breast between her two fingers as indicating the coming maternity of Gabrielle d'Estrées. However, within the broader context of erotic art practices of the time, the ostensive gesture of the Duchess points to something else. It is a gesture of *demarcation* which echoes the procedure of fragmentation to which the feminine body was subjected in the numerous and repetitious literary descriptions of its beauties, enumerations of its parts. Here Michelson draws a parallel between the gesture of demarcation which, in bringing a particular part of the body to attention, *detaches* it from that body, and the highly fashionable and somewhat scandalous poetic form which took as its subject not the entirety, but one part only of the feminine body. This poetic glorification of the anatomical fragment was known as the *blason anatomique* and there were as many *blasons* as the imaginary fragmentation of the woman's body into elected zones of pleasure would allow: *le blason du pied, blason des cheveux, blason du sourcil, blason de la cuisse, blason de l'oreille, blason de l'ongle, blason du C.* [con], *blason du Q.* [cul], *blason du tétin*, and so on.[2]

The analogy Michelson draws between the structure of the portrait and the form of the blason is suggestive, and I shall pursue it later. For the moment, I wish to return briefly to the text which prompted this analogy, Villiers's description of the beautiful Alicia.

> Her thick dark hair has the sheen of the southern night.... Her face is the most seductive of ovals. Her cruel mouth blooms like a bleeding carnation drunk with dew. Moist lights linger playfully upon those lips, which reveal in dimpled laughter the brilliance of her strong young animal teeth. And her eyebrows quiver at a shadow. The lobes of her delightful ears are cool as April roses. Her nose, exquisite, straight, with lucent nostrils, extends the forehead plane... Her hands are pagan rather than aristocratic; her feet as elegant as those of Grecian statues...[3]

To me, the description of the beautiful Alicia, 'inventory of her beauties' Michelson writes, suggests another model: 'Composed as one notes, of details, it proceeds, one also notes downward, from shining tresses to elegant feet...'[4] The model evoked here recalls that of late medieval descriptive poetry, the systematic listing of physical parts from the head downward, of which Boccaccio's *canone lungo* is an instance.[5] Without denying the connection between the older descriptive tradition and the more recent poetic form of the *blason anatomique*, it is nevertheless important to differentiate between, respectively, the cumulative process of the enumeration of parts, and the highly selective process of demarcation whereby one part only is abstracted from the totality of the feminine body:

[1] Annette Michelson, 'On the Eve of the Future: The Reasonable Facsimile and the Philosophical Toy', *October* 29, Summer 1984.

[2] Although the term *blason* is sometimes used to refer to any descriptive text in praise of an object, (see for example Patricia Parker 'Rhetorics of Property: Exploration, Inventory, Blazon', *Literary Fat Ladies*, Methuen, London New York, 1987, pp.126-154 or Roland Barthes, *S/Z*, Jonathan Cape, London 1975, pp.113-4) I shall speak here specifically of the French form of the *blason anatomique*, eulogy of the body fragment, contrasting it to earlier poetic descriptions of the whole feminine body.

[3] Villiers de l'Isle-Adam, in, A. Michelson 'On the Eve of the Future', op.cit., p.6.

[4] A. Michelson, op.cit., p.8.

[5] The *canone lungo* takes as its object the entirety of the feminine body. See for instance Boccaccio's 'Teseida', XII, 53-63, in *Opere in Versi*, Ed. P.G. Ricci, Milan 1965, pp.412-15.

Petit nombril, que mon penser adore,
 Non pas mon oeil, qui n'eut onques ce bien,
 Nombril à qui l'honneur mérite bien,
 Qu'une grande ville on luy bastisse encore:
Signe divin, qui divinement ore
 Retiens encore l'Androgyne lien,
 Combien & toy, mon mignon, & combien
 Tes flancs jumeaulx follastrement j'honore!
Ny ce beau chef, ny ces yeulz, ny ce front,
 Ny ce doulx ris, ny ceste main qui fond
 Mon cuoeur en source, & de pleurs me fait riche,
Ne me scauroyent de leur beau contenter,
 Sans esperer quelque foys de taster
 Ton paradis, où mon plaisir se niche.[6]

In the single space of the portrait of Gabrielle d'Estrées and the Duchesse de Villars we are given both the totality of the feminine body and its fragmentation. In the seated figure of the working nurse we are presented with a body closed in upon itself and set apart from the dominant mise-en-scène of pleasure and desire — a clothed nucleus around which circulate the dispersed fragments of nakedness. Rather than inviting a gathering of those fragments into a totality, the formal pictorial construction of the painting further enhances their disjunction and isolation by presenting us with a number of embedded frames: from the framing edge of the picture as a whole we move to the framing device of the parted and lifted curtains which reveal the sisters d'Estrées, who are further contained within the rectangular surround of the bath; behind these primary figures, a further pair of curtains open upon the scene of the nurse, who in turn is pictured seated before the two framed paintings on the wall behind her. Background and foreground therefore are demarcated as if by a succession of theatrical 'flats', a series of narrow spaces which seem both to emanate from, and to culminate in, the enclosure of the nipple between the finger-tips.[7] The process of demarcation sustained throughout the painting is ultimately a process of selection, that is, of exclusion. 'Not this handsome head... nor these eyes... not this forehead... nor this sweet laughter... not this hand...', but the small navel writes Ronsard. Not the entirety of the woman's body, but a 'detachable' fragment — the nipple, or the legs in the background reduced through perspective to the size of the fingers which enclose the nipple — an insignificant fragment which transfixes the viewer's gaze and comes to occupy the space of a poem, the space of a painting, the space of the body.

II

Commentators on the *blason* are agreed in locating the specific origin of the form in the late medieval tradition of descriptive poetry, and in more generally ascribing it to the will to rationalise the human environment which comes to dominate intellectual and artistic thought in the Renaissance. The term *blason* itself comes out of the earlier tradition of heraldry: it was the name given to a painted miniature of a particular shield accompanied by a brief description and interpretation of its features. The didactic function of those early *blasons* was carried over into the production of poetic compendia such as *calendriers* and *bestiaires*. The *calendriers* provided the reader with a description of the characteristic features of each month and season and of the work

[6] Pierre de Rondard, *Les Amours*, sonnet LXXII, (1552), Garnier Frères, 1963, p.45. Although Ronsard's
 blason sonnet does not exemplify the form of the *blason anatomique*, it nonetheless provides a succinct
 exposition of the dynamics of the *blason*.
[7] Note in the background the bottom left corner of a painting of a reclining figure in which all we are allowed
 to see are the legs — slightly spread apart in a configuration which mirrors the position of the thumb
 and index finger of the Duchess de Villars.

to be done in each of them. The *bestiaires* similarly offered brief poetic descriptions of individual animals combined with moral reinterpretations of their characteristics. Stones, plants, human types and other products of nature were subjected to the same process of 'rationalisation'. The *blason anatomique* emerged within the extensive revival in the Renaissance of the didactic form of the compendium which produced more *calendriers*, more *bestiaires*, and a wealth of emblem books.

At the same time, in Italy, Olympo da Sassoferrato was writing what Saunders describes as 'anatomical love poetry' — *capitoli* and *strombotti* on the beauties of women. The *capitolo del bianco petto de madonna Pegasea* is a long poem in praise of the beauty of a certain lady Pegasea's breasts and is often tentatively cited as the possible inspiration for the first anatonomical *blason*, Clément Marot's *Beau Tétin*. The *strombotto* is a shorter eight-line poem about one feature of the feminine body, of which Sassoferrato wrote no less than forty-five collected under the heading *Comparation de laude a la signora mia incominciando al capo per insino a li piedi*. Whether or not Clément Marot had read Sassoferrato's anatomical poetry before writing his *blason* is still subject to debate and Saunders indeed stresses the difference between the elliptical discourse of Sassoferrato's poems — 'evoking a series of disconnected and precious images' [8] — and the more direct descriptive approach in Marot's *Blason du Beau Tétin*. However, for my purpose here I wish to simply remark that in sixteenth century poetry, the feminine body became the site where the will to order, to categorise, to repertorise, ultimately the will to master, and desire came together. This dual impulse found its most concise poetic expression in the *blason anatomique* in France during the period between 1536 and 1543.

Renaissance poetic discourses on the body fragment emerged in the context of a wider preoccupation with the structure of the human body which led to the formulation of the theory of proportions and the articulation of the scientific system of *anatomy*. In anatomy the idealised body — that is the body considered as a *whole* — was violently destroyed; it was sectioned, dissected in the process of creating a new field of scientific knowledge; fragmentation was the means of getting at a unified truth. In art, the existential body was idealised. It was given an organic coherence in the drawing of internal correspondances between its constitutive parts — the proportion of one finger to the other, of all the fingers to the rest of the hand, of all parts to all others and so on. The part became the measure of the whole. 'Therefore there shall be revealed to you here in fifteen entire figures the cosmography of the "minor mondo" in the same order as was used by Ptolemy before me in his Cosmography. And therefore I shall divide the members as he divided the whole, into provinces, and then I shall define the functions of the parts in every direction, placing before your eyes the perception of the whole figure and capacity of man in so far as it has local movement by means of its parts.'[9] The works of Leonardo da Vinci best attest to a concern both for an understanding of the mechanics of the human body based on anatomical observations, and for the representation of that body as a harmonious totality — a totality based on the formulation of correspondances between as many parts of the body as possible.

Thus defined across two systems, the human body was subjected, by the same hand, both to the aggressive act of sectioning, dissecting, and to the totalising act of representation. Devon L. Hodges argues for a similar dualism at work in the illustrations of Andreas Vesalius' *De Corporis Fabrica*, a dualism which he perceives as a tension between the belief in the body as an ideal form, and the body as dehumanised parts — fragments of matter across an anatomy textbook.[10] The six illustrations — from the drawing of a heroic standing male figure, displaying the superficial muscles, to that of a poised skeleton — read as a narrative of the destruction of the ideal body. However, the artist never completely surrenders the ideal to the gruesome materiality of anatomical scrutiny. The expressions, poses and settings belong to a rhetoric of art rather than to a more succinct, 'objective', strictly illustrative intention.

[8] Alison Saunders, *The Sixteenth-Century Blason Poétique*, University of Durham Publications, Peter Lang, Bern, Las Vegas, 1981, p.95.

[9] Edward McCurdy (ed), *The Notebooks of Leonardo da Vinci*, vol.I. Jonathan Cape, London, 1938, p.168.

[10] Devon L. Hodges, *Renaissance Fictions of Anatomy*, The University of Massachussets Press, Amherst, 1985, pp.4-6.

The Renaissance propensity to categorise and repertorise found in the anatomical act of sectioning and dissecting a favoured metaphor. We may note, for example, the emergence of 'spiritual' anatomies, moral works whose aim was to purify by cutting away the sins which conceal the truth. The 'body' here is not the human body, but that of the religious text which was subjected to aggressive critical scrutiny in order to rid it of its ailing parts [11] — a process which partakes of what we would now recognise as pathology. However, the analogy drawn between the analytical and the anatomical process invites reinterpretation: the violence done to the body of the religious text can be as easily read as violence done to the sexual body, a mortification of that 'flesh' which Christianity perceived as 'diseased'.

In giving a brief account of the context within which the *blason anatomique* came to prominence, I have tried to situate the form within the dynamics of the ambivalence of a totalising impulse — the search for 'true' knowledge (be it mediated by the scalpel, the paintbrush or the word) which took the human body apart, scattering its fragments across the Renaissance imaginary. This ambivalence suggests a reading of the *blason anatomique* which would take into account the tacit aggressivity of a poetic form which, in praising the part, violently undoes the feminine body.

III

Tétin refaict, plus blanc qu'ung oeuf,
Tétin de satin blanc tout neuf,
Tétin qui fais honte à la rose,
Tétin plus beau que nulle chose;
Tétin dur, non pas Tétin, voyre,
Mais petite boule d'ivoyre,
Au milieu duquel est assise
Une fraize, ou une cerise
Que nul ne veoit, ne touche aussi,
Mais je gaige qu'il est ainsi.
Tétin donc au petit bout rouge,
Tétin qui jamais ne se bouge,
Soit pour venir, soit pour aller,
Soit pour courir, soit pour baller.
Tétin gauche, tétin mignon,
Toujours loing de son compaignon,
Tétin qui porte tesmoignage
Du demourant du personage.
Quand on te voit, il vient à maintz
Une envie dedans les mainz
De te taster de te tenir;
Mais il se faut bien contenir
D'en approcher, bongré ma vie,
Car il viendroit une aultre envie.
 O Tétin ne grand ne petit,
Tétin meur, Tétin d'appetit,
Tétin qui nuict et jour criez:
"Mariez moy, tost mariez!"
Tétin qui t'enfles et repoulses
Ton gorgerin de deux bons poulses,
A bon droict heureux on dira
Celluy qui de laict t'emplira,
Faisant d'un Tétin de pucelle
Tétin de femme entiere et belle.[12]

In his postface to *Les Blasons anatomiques du corps féminin,* Pascal Quignard speaks of the recognition of our adult body as evolving out of the early perceptual experience of fragments. He speaks of a mouth which encircles a nipple; a thumb; a hand that gently waves goodbye; two eyes, symmetrical and shiny; a mouth that vomits; an inclining head of thick hair; legs that give way; fragments which fill the perceptual space of our earliest days and which we try to assemble in a coherence which we will make our own. He also speaks of the impossibility of sustaining a coherent image of a body which fails us incessantly — an illness, pain, a feature we dislike, perhaps a scar, or birthmark — and the unity is destroyed as the fragment malignantly invades our perception. Quignard does not further elaborate on this; nonetheless his remarks suggest a discussion of the *blason anatomique* grounded in considerations of *identity:* the construction of identity as coherence and the subsequent threat to that precarious unity.

The infant's relation to the external world is to part-objects, body fragments which, because of their role in bringing pleasure and relief, dominate the earliest perceptual experience; as yet there is no apprehension of a distinct unity, a whole object, a person. Privileged amongst those part-objects is the breast as the experience of feeding initiates an object-relation to the mother. In Melanie Klein's account of the earliest relation to part-objects,[13] the breast is perceived by the infant as being at one and the same time a 'good' breast and a 'bad' breast: 'good' in so far as it brings relief from hunger and therefore a source of pleasure; 'bad' is so far as, in its absence, it becomes associated with the frustration and discomfort arising from hunger. The infant projects its feelings of love and hate towards respectively the 'good' and the 'bad' breast while simultaneously intro-jecting a 'good' and a 'bad' breast since sensations of pleasure and pain come from inside its body. The feeling of hatred which arises from frustration engenders phantasies of destruction in which the infant bites and tears up the breast, devouring and annihilating it. The breast — 'good' or 'bad' — is phantastically endowed with powers comparable to that of a person. The 'bad' breast, internal and external, is therefore capable of turning against the infant and retaliating.

On the other hand, the power of the 'good' breast is increased to the point of idealisation; hallucinatory gratification turns the breast into an inexhaustible source of pleasure and affords the infant temporary omnipotence — total control over the external and the internal idealised breast which it possesses. The degree to which feelings of hate and feelings of love are kept apart in the splitting of the object into a 'good' and a 'bad' object varies considerably. There are times when some degree of synthesis is achieved between destructive impulses and feelings of love; this gives rise to experiences of ambivalence in relation to the part-object and triggers the urge to make repara-tion to the injured 'good' breast, to put its fragments back together, to restore it to its state of wholeness.[14]

Without attempting an *exhaustive* mapping of the structure of such early psychic processes onto the poetic form of the *blason* (which I do not believe could succeed) I nevertheless wish to con-sider the relevance of the Kleinian dialectic — which takes as its object the infant's phantastical investment in a part of the maternal body — to the poetic veneration of a fragment of the woman's body. As Klein stresses, 'the mother's breast both in its good and bad aspects, also seems to merge for him (the infant) with her bodily presence; and the relation to her as a person is thus gradually built up from the earliest stage onwards.'[15]

[11] One such work by Augustine Mainardo was entitled: *An Anatomy: that is to say A parting in peeces of the Mass. Which discovereth the horrible errors and the infinite abuses unknowen to the people aswel of the Mass as of the Mass book* (1557).

[12] Yves Giraud (ed), *Clément Marot, Oeuvres Poétiques,* Garnier-Flammarion, 1973, p.402.

[13] Melanie Klein, 'Some theoretical conclusions regarding the emotional life of the infant', *Developments in Psycho-analysis,* The Hogarth Press Ltd, London, 1952.

[14] The state of ambivalence being anxiogenic to the infant is always kept in check by the process of splitting of the object and is relatively unfrequent in the earliest months of the infant's life. As development pro-ceeds, the experience of ambivalence toward the object recurs more frequently, giving rise to longer states of depressive anxiety.

[15] Melanie Klein, op.cit., p.200.

Enumeration of physical features of beautiful women, in late medieval descriptive poetry, has often been compared to a process of fragmentation of the feminine body.[16] The *blason anatomique* can be regarded as a further stage where, from the scattered fragments, only one is chosen, and in its turn subjected to fragmentation — the poetic scrutiny of the object.[17] D.B. Wilson speaks of the spiralling movement of the poem, 'in the way in which it continually revolves around the object describing each new angle by a series of qualifications...'.[18] To me, the rhythm of the poem, punctuated here and there by the repetition of the same word,[19] suggests a more disjuncted movement, and the description of each new angle of the object is more like a scattering of that object into disparate images: 'Tit whiter than egg, tit of new brand new white satin... little ivory ball in the middle of which a strawberry or cherry sits... tit which night and day cry, "Marry me, marry me soon!" '

Characteristic to the form of the *blason anatomique* is the invocatory address whereby the body-fragment is spoken to as if it were a person. The part takes on the status of the whole. Like the living woman, it is at times endowed with speech, but it is often given a far greater power, that of life and death over the enamoured poet:

...O sourcil brun soubz tres noires tenebres
j'ensepvly en desirs trop funebres
Ma liberte en ma dolente vie
'Qui doucement par toy me fut ravie.[20]

...Front apparent, affin qu'on peust mieulx lire
Les lois qu'amour voulut en luy escrire,
O front, tu es une table d'attente
Où ma vie est, et ma mort trés patente.[21]

The ambivalence inherent to the form of the *blason anatomique* — the idealisation of the object in laudatory verses premised on the aggressive fragmentation of the feminine body — is here echoed in the content of the poems. The body-part is turned into a phantasmatic part-object, purveyor of pleasure and frustration, ultimately of life and death. In Marot's *Du Beau Tétin*, the formulation of the ambivalence between idealisation and destruction is of particular interest here. *Du Beau Tétin* was the first anatomical blason and the model from which the fad for writing verses about the fragment of the feminine body evolved. It seems significant that the object of the first *blason anatomique* should have been the breast, the *first* object of infancy. The play of metaphors and metonymies in the opening verses suggests something of that early perceptual experience of the part-object. The poetic breast is made into a tangible object — palpable, *palatable*. It has the smoothness of satin, the firmness of ivory. The breast is egg, strawberry or cherry; it becomes the food that it itself contains. The poetic sliding from the breast that feeds to the breast as food

16 See for example, Mario Pozzi, 'Il ritratto della donna nella poesia d'inizio cinquecento', in *Lettere Italiane*, Anno XXXI-N1, Gennaio-Marzo 1979, Francois Lecercle, *La Chimère de Zeuxis*, Gunter Narr Verlag Tübingen 1987

In Roland Barthes' words, '.... once reassembled, in order to *utter* itself, the total body must revert to the dust of words, to the listing of details, to a monotonous inventory of parts, to crumbling: language undoes the body....', *S/Z*, Jonathan Cape, London, 1975, p.113.

17 It is worth noting that in their published form — that is collected in a compendium — each of the *blasons anatomiques* becomes but a sentence, a section in a long enumeration of the parts of the feminine body.

18 D.B. Wilson, *Descriptive Poetry in France from Blason to Baroque*, Manchester University Press, Barnes & Noble, Inc., New York, 1967, p.8.

19 The repetition throughout the poem of the name of the body-part under scrutiny was a common feature of all *blasons anatomiques*. In Francois Sagon's *Blason du Pied* each of the forty-four lines of the poem begins with an invocation to the *pied*.

20 Maurice Scéve, 'Blason du Sourcil', *Oeuvres Poétiques Complètes*, Bertrand Guégan (ed), Slatkine Reprints, Genève, 1967, p.282.

21 Maurice Scève, 'Blason du Front', ibid. p.283.

replicates the fluctuating perception the infant has of the maternal breast — the 'good' breast that provides nourishment and satisfaction, the 'bad' breast which, in its oral-destructive phantasies, the infant bites, tears up and devours.

In the same way as the beginning of the poem suggests fragmentation, the four last verses evoke coherence: the coherence of one idea smoothly carried across, in contrast with the overall movement of the poem, punctuated by repetition and broken into a series of brief disparate images. The formal fragmentation resolves into formal coherence just as the tearing apart of the breast resolves into the reparatory act of filling it with milk, of making it *whole* again. Reparation is made to the injured loved object.

Of the dialectic of idealisation and destruction at work in the *blason anatomique* Annette Michelson writes: 'Woman, subjected to the analytic of dissection is then reconstituted, glorified in entirety and submission: as Marot says in his *Blason du Beau Tétin,* "He who shall with milk make you swell, makes a virgin's tit that of a woman, whole and fine".[22]

Encouraged by the success of his *Blason du Beau Tétin,* Clément Marot promptly launched the idea of the *contre-blason.* However his *Blason du Laid Tétin* failed to please. The *laid tétin* is the breast of the aging woman, withered and barren. It is the 'bad' breast, purveyor of death, object of the child-poet's most aggressive impulses:

... Tétin grillé, tétin pendant,
Tétin flaitry, tétin rendant
Villiane bourbe en lieu de laict,
Le diable te feit bien si laid.
Tétin pour trippe reputé,
Tétin ce cuyde-je emprunté
Ou desrobé eb quelque sorte
De quelque vieille chievre morte...[23]

The ambivalence at work in the *blason* — the dissection of the feminine body in laudatory verses — is absent from the *contre-blason* reduced as it is to the sole violence of a depreciatory discourse. Melanie Klein says that early perception does not allow for ambivalence; the breast is simply *split* into a 'good' object and a 'bad' object. As the child's perception evolves, however, feelings of ambivalence toward the part-object become more frequent. In this light, it becomes possible to consider the productions of *blasons* and *contre-blasons* with more specific reference to those two stages in the evolution of the child's relation to the part-object: the *blason* as the product of an ambivalent perception when 'good' and 'bad' qualities are attributed to the same object; the *contre-blason* as stemming from a more archaic perception, when the object is *absolutely* 'bad' and as such becomes the recipient of focussed, unconditional and intense hatred.[24] The sight of the aged breast incites the poet to violence, a desire to 'slap about the face five or six times' its bearer:

...Tetasse à jecter sur l'espaule
Pour faire, tout bien compassé,
Un chaperon du temps passé.
Quand on te voit, il vient à mainzt
Une envie dedans les mainz
De te prendre avec gand doubles

[22] A. Michelson, 'On the Eve of the Future'. op.cit., p.10.

[23] Clément Marot, 'Contreblason du Tétin', *Blasons anatomiques du corps féminin,* Pascal Lainé (ed), Gallimard, 1982, p.118.

[24] It can be assumed that the aggessivity (and love) directed at an object which is perceived to be, at one and the same time, 'good' *and* 'bad' will be a lesser intensity than the feelings directed at an object which is perceived to be wholly 'good' *or* wholly 'bad'.

Pour en donner cinq ou six couples
De souffletz sur le nez de celle
Qui te cache soubz son esselle! [25]

IV

The distinction made between descriptive poetry that takes as its object the entirety of the feminine body and the highly selective poetic form of the anatomical *blason* suggests a further nuance. Speaking of Villiers de l'Isle-Adam's rendering of the beauties of Alicia, Annette Michelson notes that the description proceeds downward from tresses to feet, '...rather like the male glance of inspection which, as in French, *toise d'un regard*, takes the measure or stock of its object'. [26] The gaze implied by the enumeration of the parts of the feminine body is therefore a gaze that *moves*, lingeringly sliding across that body. On the other hand, the close poetic scrutiny of the body-part in the anatomical *blason* suggests a gaze which has come to rest — *arrested*. I am reminded here of Freud's account of the origins of fetishism — the averted gaze that comes to rest on a fragment which thereafter will serve to allay the castration anxiety by serving as a substitute for that which the little boy construes as missing from the woman's body. This 'insignificant' fragment upon which the imaginary remains fixated, not only comes to stand as the absent penis, but is further elevated to the status of the phallus — signified of omnipotence of which the male organ is the (ever inadequate) signifier.

Indeed, the *beau tétin* displays qualities not dissimilar to that of the erect penis: it is as hard as ivory, it swells, pushing back the garment that shields it, and it is at its best when replete with 'milk'. Furthermore, the idealised tit takes on the status of an idealised whole — not merely the entirety of the body of which it is a part, but an *imaginary* wholeness which exists beyond the actuality of a complete body, of the woman. [27]

Having positioned the production of anatomical *blasons* within the dynamics of fetishism how am I to account for the *Blason du C.*, which takes as its object precisely that from which the fetishist averts his gaze? The *Blason du C.*, is a spirited eulogy of the woman's cunt. The *con* is likened successively to the bold lion, the audacious greyhound, the agile and playful monkey or kitten; it is spring, fountain and rivelet; it is a narrow path which leads to a delightful sojourn; it is a small receptacle secured by a ruby clasp; it is a dainty morsel, and so on. The written cunt therefore is *excessive* . That which the male imaginary construes as the mark of an absence is turned, through accumulation and displacements, into a compensatory cornucopia — 'I know very well there is nothing there, but nevertheless everything is there'.

The *Blason du C.*, a spirited eulogy which nevertheless bears the mark of ambivalence toward its object in the very rhetoric of its construction, a rhetoric dominated by antithesis; source of both pleasure and anxiety, the *con* is at once lion and dainty morsel; it is at once the devouring mouth and the delectable food to be devoured.

In her 1981 essay 'Diana described: Scattered Woman and Scattered Rhymes'[28], Nancy J. Vickers

[25] C. Marot, 'Contreblason de Tétin', *Blasons anatomiques du corps féminin*, op.cit., p.118.

[26] A. Michelson, 'On the Eve of the Future', op.cit., p.8.

[27] The part-object which the fetishist elects as fetish is not necessarily a body-part, and as Freud remarks, it is not necessarily an object. Blasons have been written which took as their objects a tear or a sigh, hence following the earlier tradition of the *strombotto* which, from the description of parts of the feminine body slid into descriptions of the garment or a fragment of the garment worn by the woman, of objects she possessed such as a mirror, and so on.

[28] Nancy J. Vickers, 'Diana described: Scattered Woman and Scattered Rhymes', *Critical Inquiry*, vol.8, Winter 1981.

considers the dynamics of fragmentation in Petrarca's writings on Laura [29] by way of a myth of mutilation — that of the male body in the Ovidian myth of Actaeon. Upon seeing the naked body of Diana, Actaeon is turned into a stag by the vengeful goddess; he is then hunted to death by his own hounds, who dismember him. Petrarca's *Canzone 23* relates an imaginary encounter between the unrequited lover and the dazzling nakedness of the woman he desires. Like Actaeon, the poet undergoes metamorphosis at seeing a forbidden nakedness, but unlike Actaeon he escapes the fate of dismemberment. Vickers writes:

> The Actaeon-Diana encounter.... reenacts a scene fundamental to theorising about fetishistic perversion: the troubling encounter of a male child with.... female nudity, with a body that suggests the possibility of dismemberment. Woman's body, albeit divine, is displayed to Actaeon, and his body, as a consequence, is literally taken apart. Petrarch's Actaeon, having read his Ovid, realizes what will ensue: his response to the threat of imminent dismemberment is the neutralization, through descriptive dismemberment, of the threat. He transforms the visible totality into scattered words, the body into signs...[30]

The link thus established between the discursive fragmentation of the feminine body and the imaginary dismemberment of the male body upon seeing 'naked femininity', succinctly and effectively reinserts the materiality of the male body into the space of the text, reminding us of the fact that the poetic discourse issues from within that body — a social body, without doubt, but more fundamentally a *sensuous* body. It further brings to the forefront the intensity of affect with which the threat is perceived: an intensity of affect which turns an imaginary threat into its literary 'actualisation', in an hallucinatory impulse which invokes the dynamics of those early perceptual experiences when 'reality' and fantasy are as yet indistinguishable.

Finally, Vickers' reading of the tale of Actaeon's encounter with Diana, as the literary *reenactment of a trauma* affords us a further insight into the underlying narratives of the poetic productions of 'beautiful fragments'. The particular narrative I am referring to here is that of the child at play, who repeatedly throws out of sight a wooden reel attached to a piece of string to then retrieve it to the joyful utterance of 'da' [there][31]. This game of loss and recovery, Freud interprets as the reenactment of the departure and return of the child's mother. He first suggests that the distressing experience of the disappearance of the mother would here be re-staged as a necessary preliminary to the pleasure of her return. Unsatisfied with this explanation which does not account for the fact that the first part of the action — the reenactment of the loss — is performed far more than the second, Freud seeks another interpretation in the play of power relations. In staging the disappearance of the object/mother, the child now takes an *active* part in a scenario where it previously was but the passive victim. The instinct for mastery would therefore operate independently of the affects attached to the memory. Keeping to the dynamics of those early power relations, Freud further attributes a meaning of defiance to the act of throwing the object, which would now be a means toward the satisfaction of the child's impulse for revenge upon his mother. Petrarca re-writes the tale of Actaeon's encounter with the goddess, casting himself in the role of the unfortunate voyeur, hence re-enacting, on paper, the unpleasurable experience of which the Ovidian tale is already the discursive staging. This repetitive reenactment of a *pre-oedipal* trauma at the level of language is the re-assertion of *symbolic* mastery over the imaginary threat embodied in the feminine form — analogous to a grown-up version of the 'fort-da' game. Petrarca, writer and *actor*, suspends the narrative of his own downfall, in a further act of mastery, at the critical moment, saving himself from bloody dismemberment. The body of Laura he will scatter into a constellation of literary fragments; painterly fragments across the canvas.

[29] Another precursor to the form of the *blason anatomique* is Francesco Petrarca's sonnet in praise of the hand of Laura. Of the influence of Petrarcan writings upon later poetic descriptions of beautiful women, Elizabeth Cropper asks: '... how the conventional description of the beautiful woman became so closely associated with a lyric poet who never painted her complete portrait'. ('On Beautiful Women, Parmigianino, Petrarchismo, and the Vernacular Style', *The Art Bulletin*, p.386.)

[30] N.J. Vickers, op.cit., p.273.

[31] Freud, 'Beyond the Pleasure Principle', *SE vol. XVIII*, Hogarth Press, London, 1955, pp.7-43.

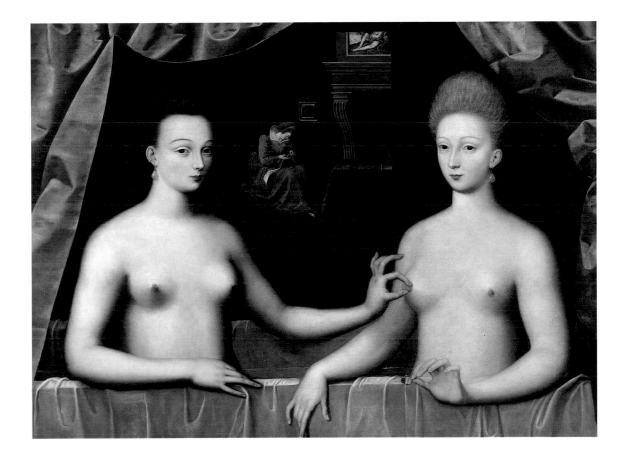

School of Fontainebleau

Gabrielle d'Estrées and the Duchess of Villars in Their Bath c.1594

Louvre, Paris

DETAILS FROM HAWTHORNE

John X Berger

Zenobia was truly a magnificent woman. It was wronging the rest of mankind to retain her as the spectacle of only a few. Her womanliness incarnate compelled me sometimes to close my eyes, as if it were not quite the privilege of modesty to gaze at her.

Hollingsworth was fast going mad. It required all the constancy of friendship to restrain his associates from pronouncing him an intolerable bore. His specific object was to obtain funds for the construction of an edifice devoted to the reform and mental culture of criminals.

One always feels the fact when one has intruded on those who love, or hate, at some acme of their passion that puts them into a sphere of their own. The intentness of their feelings gives them the exclusive property of the soil and atmosphere, leaving one no right to be there.

Priscilla produced from a work-bag some little wooden instruments and proceeded to knit a silk purse. I remembered having been the possessor of just such a purse. Its peculiar excellence lay in the almost impossibility that any uninitiated person should discover the aperture.

The pathway of that walk still runs along, with sunny freshness, through my memory.
I know not why it should be so. My mental eye can even now discern the September
grass, bordering the pleasant roadside with a brighter verdure than while the summer
heats were scorching it.

Priscilla had been brought up in some inauspiciously sheltered court of the city, where the uttermost rage of a tempest could not shake the casement of her little room. A little parallelogram of sky was all that she had known of the awfulness of nature's limitless extent.

It is not a healthy kind of mental occupation, to devote ourselves to the study of individual men and women. If we take the freedom to put a friend under a microscope, we magnify his peculiarities and thereby isolate him from many of his true relations.

Her manner bewildered me. It struck me that here was the fulfillment of every fantasy of an imagination revelling in various methods of self-indulgence and splendid ease. It cost me a bitter sense of shame, to perceive in myself a positive effort to bear up against the effect which Zenobia sought to impose.

I have known him to begin a model of the building in which his philanthropic dream strove to embody itself, with little stones gathered by the brookside. Unlike all other ghosts, Hollingsworth's spirit haunted an edifice which, instead of being time-worn and full of storied love, had never materialised.

CONNOISSEURS

Karen Knorr

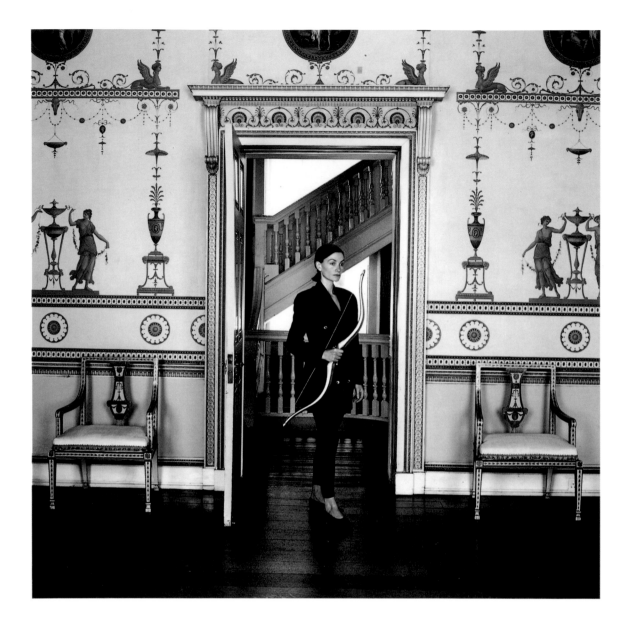

Shattering an Old Dream of Symmetry

at Osterley House

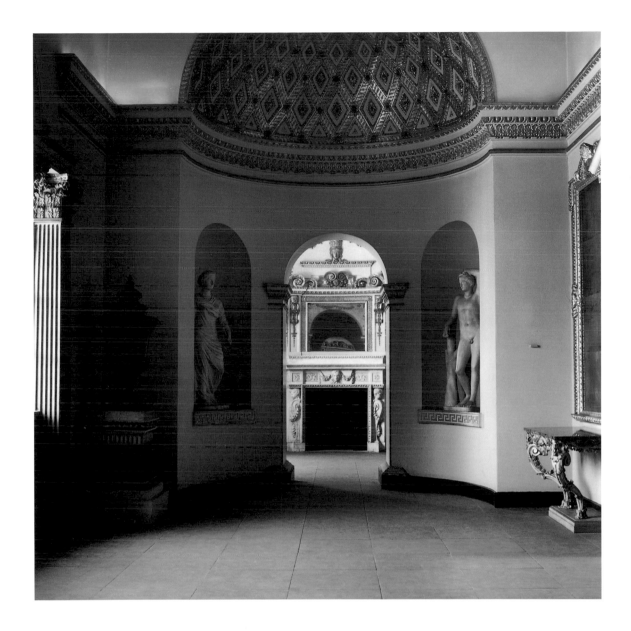

Antiquity as a Guide to Nature

at Chiswick House

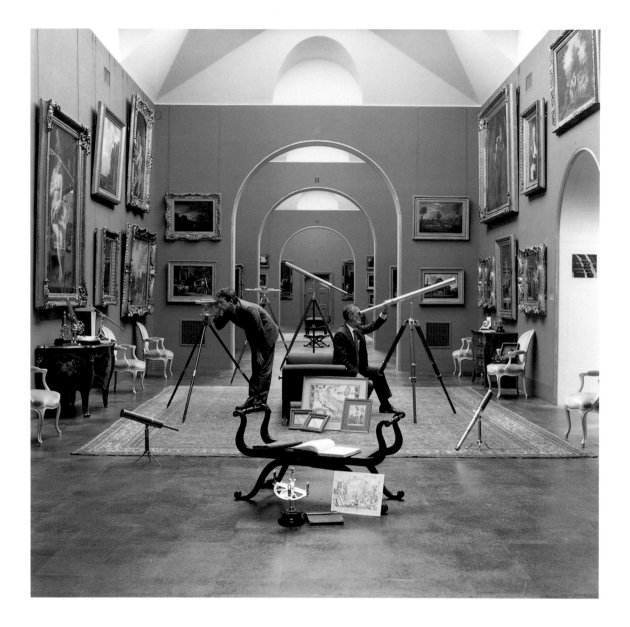

The Analysis of Beauty

at The Dulwich Picture Gallery

The Invention of Tradition

at The Sir John Soane Museum

Pleasures of the Imagination

at The Dulwich Picture Gallery

Thoughts on the Imitation of Ideas

at The Dulwich Picture Gallery

The Genius of the Place

at Osterley House

The Demise of Logos

at Osterley House

THE SKULL OF CHARLOTTE CORDAY

Leslie Dick

Dismembered limbs, a severed head, a hand cut off at the wrist... feet which dance by themselves... all these have something peculiarly uncanny about them, especially when, as in the last instance, they prove capable of independent activity in addition. As we already know, this kind of uncanniness springs from its proximity to the castration complex. To some people the idea of being buried alive by mistake is the most uncanny thing of all. And yet psychoanalysis has taught us that this terrifying phantasy is only a transformation of another phantasy which had originally nothing terrifying about it at all, but was qualified by a certain lasciviousness — the phantasy, I mean, of intra-uterine existence.[1]

ONE: 1889

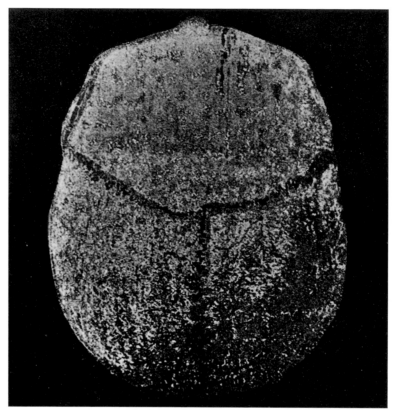

Skull of Charlotte Corday (Fig. 1)

Controversy at the Universal Exposition in Paris, on the centenary of the Revolution, as rival craniologists examine the skull of Charlotte Corday, kindly loaned for exhibition by Prince Roland Bonaparte, great-nephew of Napoleon and noted anthropologist, botanist, and photographer.

Professor Cesare Lombroso, criminal anthropologist, insists (after a brief examination of the skull) that specific cranial anomalies are present, which confirm his theory of criminal types, or 'born criminals'. He subsequently uses three photographs of the skull of Charlotte Corday, in his book *La Donna Delinquente, la Prostituta e la Donna Normale* (Turin, 1893, co-written with Guglielmo Ferrero, translated into English and published in 1895 as *The Female Offender*) to demonstrate that Corday, despite the pure passion and noble motive of her crime, was herself a born criminal, and therefore in some sense destined to murder:

Political criminals (female). — Not even the purest political crime, that which springs from passion, is exempt from the law which we have laid down. In the skull of Charlotte Corday herself, after a rapid

[1] Sigmund Freud, 'The Uncanny', (1919), S.E. XVII, p.244.

inspection, I affirmed the presence of an extraordinary number of anomalies, and this opinion is confirmed not only by Topinard's very confused monograph, but still more by the photographs of the cranium which Prince R. Bonaparte presented to the writers, and which are reproduced in Figs. 1, 2, 3.

The cranium is platycephalic, a peculiarity which is rarer in the woman than in the man. To be noted also is a most remarkable jugular apophisis with strongly arched brows concave below, and confluent with the median line and beyond it. All the sutures are open, as in a young man aged from 23 to 25, and simple, especially the coronary suture.

The cranial capacity is 1,360 c.c., while the average among French women is 1,337; the shape is slightly dolichocephalic (77.7); and in the horizontal direction the zygomatic arch is visible only on the left — a clear instance of asymmetry. The insertion of the sagittal process in the frontal bone is also asymmetrical, and there is a median occipital fossa. The crotaphitic lines are marked, as is also the top of the temples; the orbital cavities are enormous, especially the right one, which is lower than the left, as is indeed the whole right side of the face.

On both sides are pteroid wormian bones.

Measurements — Even anthropometry here proves the existence of virile characteristics. The orbital area is 133 mm.q., while the average among Parisian women is 126. The height of the orbit is 35 mm., as against 33 in the normal Parisian.

The cephalic index is 77.5; zygomatic index 92.7; the facial angle of Camper, 85°; the nasal height, 50 (among Parisians 48); frontal breadth, 120 (among Parisian women 93.2).[2]

'The skull of Charlotte Corday herself' — Charlotte Corday, the 'angel of assassination', the beautiful virgin who fearlessly killed Marat in his bath, and calmly faced the guillotine, certain of the righteousness of her act. Corday becomes the paradigm of Lombroso's theory of innate criminality, simply because in every other respect she was so pure, so devoid of criminal characteristics. According to Lombroso, atavism in the male reveals itself in criminality; by contrast, the atavistic female is drawn to prostitution. Corday's virility is thus confirmed by her virginity.

The 'criminal type', or born criminal, is central to Lombroso's theory of anthropology. W. Douglas Morrison, Warden of H.M. Prison, Wandsworth, writes in his 1895 introduction to *The Female Offender*:

> The habitual criminal is a product, according to Dr Lombroso, of pathological and atavistic anomalies; (s)he stands midway between the lunatic and the savage; and (s)he represents a special type of the human race.[3]

Lombroso generalises with ease about the female criminal type:

> In short, we may assert that if female born criminals are fewer in number than the males, they are often much more ferocious.

> What is the explanation? We have seen that the normal woman is naturally less sensitive to pain than a man, and compassion is the offspring of sensitiveness. If one be wanting, so will the other be.

> We also saw that women have many traits in common with children; that their moral sense is deficient; that they are revengeful, jealous, inclined to vengeances of a refined cruelty.

> In ordinary cases these defects are neutralised by piety, maternity, want of passion, sexual coldness, by weakness and an undeveloped intelligence. But when a morbid activity of the psychical centres intensifies the bad qualities of women, and induces them to seek relief in evil deeds; when piety and maternal sentiments are wanting, and in their place are strong passions and intensely erotic tendencies, much muscular strength and a superior intelligence for the conception and execution of evil, it is clear that the innocuous semi-criminal present in the normal woman must be transformed into a born criminal more terrible than any man.[4]

2 Cesare Lombroso, *The Female Offender* (with Guglielmo Ferrero, London, 1895), p.33-4.
3 Ibid., p.xvi.
4 Ibid., p.150-1.

In 1889, as part of the Universal Exposition at Paris, numerous scientific congresses were held, and it was possible to attend three or four at a time. That summer, simultaneously there took place the International Congress of Physiological Psychology, the International Congress of Experimental and Therapeutic Hypnotism (participants included Freud, Myers, James, and Lombroso), and the Second International Congress of Criminal Anthropology. Many years later, Lombroso referred to that summer in Paris as that grievous or wretched time (*'dolorosa'*)[5], and this wretchedness was due, at least in part, to the violent arguments that took place between Lombroso and the French craniologists, notably Dr Paul Topinard, over the skull of Charlotte Corday. Lombroso recalled that the only truly happy moment of his stay in Paris was when he was permitted to examine the skull itself, which was entrusted to him by Prince Roland Bonaparte.

Lombroso was particularly thrilled to find, on the skull of Charlotte Corday, the median occipital fossa, upon which his theory of criminal atavism rested. Nineteen years before, in 1870, *'in un fredda e grigia mattina di dicembre'* — 'on a cold, grey December morning'[6], Lombroso performed an autopsy on the skull of Villella, a thief, and discovered this cranial anomaly, which he believed related directly to the skull formations of apes. Lombroso kept the skull of Villella in a glass case on his desk for the rest of his life, and in 1907, he wrote: *'Quel cranio fin da quel giorno divenne per me il totem, il feticcio dell'antropologia criminale.'* — 'From that day on, this skull became for me the totem, the fetish of criminal anthropology.'[7] It was the median occipital fossa that proved to be the bone of contention, so to speak, at the Second Congress.

Turning to *L'Anthropologie*, volume 1, 1890, we find, on the very first page of this first volume, the text referred to by Lombroso as 'Topinard's very confused monograph', entitled *'A propos du Crâne de Charlotte Corday'*. In this work, Topinard implicitly criticizes Lombroso's techniques of measuring cranial anomalies, but more importantly, rejects Lombroso's interpretations of these measurements. Topinard insists there is no determining connection between the shape of the skull and the psychology or behaviour of the human being:

> Our project is not to describe the skull as if it were that of a known person, the objective being to compare craniological characteristics with the moral characteristics attributed by history to this person. We only wish to take the opportunity for a study which could be carried out on any other skull, the object of which would be to place before the eyes of our readers a summary of the manner in which, in our view, given the actual state of the science, an isolated skull should be described, inspired by the methods and the very precise procedures of our illustrious and regretted teacher, Paul Broca.[8]

Topinard goes on to emphasize the importance given by the school of Broca to averages, and therefore the relative insignificance of a single skull. On the other hand, he writes, with a very precious skull, it is correct to carefully photograph and measure it, so that our grandchildren can make use of this data later, when science has progressed further. Topinard's description of the skull itself is vivid:

> The skull, before my eyes, is yellow like dirty ivory; it is shiny, smooth, as, in a word, those skulls that have been neither buried in the bosom of the earth, nor exposed to the open air, but which have been prepared by maceration [soaking], then carefully placed and kept for a long time in a drawer of a cupboard, sheltered from atmospheric vicissitudes.[9]

Topinard goes on to emphasize that, above all, the skull is normal, symmetrical, 'without a trace of artificial or pathological deformation, without a trace of illness'[10], etc. It is the skull of a woman,

[5] See: Gina Lombroso-Ferrero, *Cesare Lombroso: Storie della Vita e delle Opere*, (Bologna, 1914), and Luigi Bulferetti, *Cesare Lombroso*, (Turin, 1975).

[6] Giorgio Colombo, *La Scienza Infelice: Il museo di antropologia criminale di Cesare Lombroso*, (Turin, 1975), p.45.

[7] Ibid., p.45

[8] Dr Paul Topinard, 'A propos du Crâne de Charlotte Corday', *L' Anthropologie* (1890), vol.I, p.1.

[9] Ibid., p.1.

[10] Ibid., p.3.

23 to 25 years old (Corday was 24 when guillotined), and there follow twenty-four pages of close technical description, eschewing any overt moral or sociological commentary. In conclusion, Topinard clearly disagrees with Lombroso:

> It is a beautiful skull, regular, harmonic, having all the delicacy and the soft, but correct curves of feminine skulls.[11]

For Topinard, the crucial fact is that, quite apart from exhibiting the appropriate delicacy and softness of normal femininity, this skull is an average skull, typical of European females. Topinard admits there are a few minor asymmetries, but insists these are insignificant, merely 'individual variations'[12] on the norm. Topinard's polemic quietly but insistently defends Charlotte Corday's reputation, denying the virility, pathological asymmetry, and abnormality attributed to her by Lombroso.

Ironically, on p.382 of the 1890 volume of *L'Anthropologie*, Topinard is obliged to insert a belated Errata to his essay on the skull of Charlotte Corday. He notes that it is a rare exception that a text so full of numbers should appear without some errors of transcription or typography. He himself spotted one such error, and 'M. Lombroso' caught another. Nevertheless, he writes, these slight changes do not affect in any way the terms of his polemic. It is easy to imagine Lombroso's satisfaction upon discovering these slips.

Clearly, the disagreements between Lombroso and Topinard went deeper than techniques of measurement. Lombroso, a Jew, was against nationalism, militarism, and colonialism; a Dreyfusard, he wrote a book on anti-semitism in 1894, and was the very first socialist candidate elected to the town council of Turin in 1902. His research into pellagra, a skin disease that ravaged the peasant population, was controversial, but accurate, and he struggled for many years to have his findings recognised and acted upon. Nevertheless, Lombroso's primary scientific project of criminal anthropology depends on the construction of a hierarchy based on genetic characteristics, and on theories of atavism and degeneracy. (In 1892, Max Nordau dedicated his extremely influential and pernicious book on degeneracy to Lombroso.)

By contrast, Topinard, reviewing an anonymous polemic that proposed the forcible deportation of all seven million black Americans to Africa, in order to avoid racial disharmony, writes:

> The solution is original, but impossible to realise... Instead of indulging in such a utopia, wouldn't the anonymous author do better to say that if the black and white races do not mix in his country, this is due to the inveterate prejudice of the Americans, who create an intolerable situation for the blacks, pushing them into an isolation in which they can only see them [the whites] as the enemy, a class which humiliates them, abuses its intellectual advantages, and refuses them an equal chance in the struggle for existence.

> There is only one significant fact in the state of things revealed by this book: this is that the blacks, in the United States, after twenty years of emancipation, remain pariahs... Here it is the question of the workers, the Jewish question, the Chinese question. The Negro question is of the same kind: anthropological notions of race have no bearing on it whatsoever.[13]

Lombroso's scientific socialism would probably have come under the heading of what Gramsci later dismissed as 'Lorianismo', after Loria, the political theorist whose most striking proposal was that everyone should have their own aeroplane, a utopian vision of Los Angeles freeway urbanism long before Los Angeles existed.[14] After a lifetime spent fascinated by the skulls of people of genius, political criminals, and anarchists, Lombroso became, in his later years, a fanatical spiritualist. His

[11] Ibid., p.25

[12] Ibid., p.3.

[13] Dr Paul Topinard, 'Le problème des Nègres aux Etats-Unis et sa solution radicale', *L'Anthropologie* (1890), vol.I p.382.

[14] For Lorianism, see the poetry of Raymond Landau (aka Alexander Task), in Peter Wollen, 'The Mystery of Landau', *Readings and Writings*, (London, 1982).

death, in 1909, was marked by obituaries on the front pages of daily newspapers in Russia, the United States, and Japan. The disposal of his corpse is noteworthy; Giorgio Colombo's recent book on the Museum of Criminal Anthropology in Turin, founded by Lombroso, includes a large photograph of Lombroso's head, beautifully preserved in alcohol in a glass jar. Colombo explains:

Among the papers of the illustrious professor, his family found three different wills, made at three different times, with small variations of a familiar kind. But one disposition, constant in all three wills, clearly indicated an explicit desire of Cesare Lombroso, which his relatives must strictly observe. This required that his body be taken to the laboratory of forensic medicine, to undergo an autopsy by his colleague Professor Carrara — this was to reply, *post mortem*, to those who had accused him of only working on the bodies of the poor. His skull was to be measured and classified, and then mounted on the rest of his skeleton; his brain was to be analysed in the light of his theory of the relation between genius and madness. Whether Carrara carried this out is not known; today the skeleton hangs in a glass case in the museum, the brain in a glass jar at its feet. In another case nearby stand the receptacles containing the intestines and the face itself. What remained of the body was cremated, and the ashes are to be found in an urn in the cemetery, between the painter Antonio Fontanesi and the poet Arturo Graf.[15]

The face of Cesare Lombroso in its jar, with his squashed and moustachioed features pressed against the glass, is a sight that, once seen, is not easily forgotten.

TWO: 1927

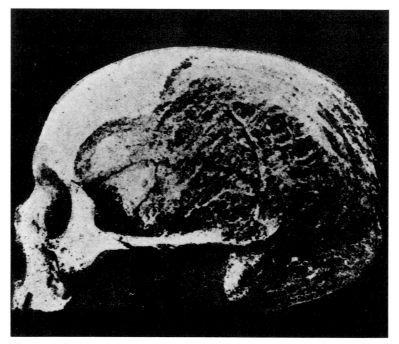

Skull of Charlotte Corday (Fig. 2)

Marie Bonaparte, aka Her Royal Highness Princess Marie of Greece and Denmark, was the only child of Prince Roland Bonaparte, owner of the skull of Charlotte Corday. She was seven years old in 1889, and later vividly remembered the inauguration of the Eiffel Tower and the Universal Exposition. She remembered also the reception that was given by her father for Thomas Edison, a very large party that included among the guests a group of American Indians in war paint and feathers. A number of different nationalities appeared as ethnographic and anthropological displays at the Exposition, imported especially for the event, to be measured by the anthropologists, and

[15] Giorgio Colombo, Op.cit., p.57.

photographed by Prince Roland.[16] The 'Peaux-Rouges', however, were represented in Paris by Buffalo Bill Cody's troupe of performers, Sioux Indians from Dakota, most of whom politely refused to allow the scientists to measure their heads and bodies. These were the guests at the Prince's reception, in honour of Edison as an American. Marie remembered asking her father for permission to attend the party, if only for a little while. He refused. She wrote to him: 'O Papa, cruel Papa! I am not an ordinary woman like Mimau and Gragra. I am the true daughter of your brain. I am interested in science as you are.'[17]

In 1923, during the long hours spent at her beloved father's bedside, as he battled with terminal cancer, Marie Bonaparte discovered Freud, through reading his *Introductory Lectures on Psychoanalysis*, which had just been published in French. As a child, Marie was particularly vulnerable to her father's frequent absences, prohibitions, and general unavailability, because her mother had died only a few days after giving birth to her. In the year of his final illness, Prince Roland could no longer leave her, and they spent every day together, taking lunch and dinner by themselves. Her father finally died in April 1924, the same month Marie Bonaparte's pseudonymous article on the clitoris appeared in the journal *Bruxelles Médical*.[18]

Marie Bonaparte was fascinated with the problem of female frigidity, a condition she herself suffered from, and her 1951 book *De la Sexualité de la Femme* (translated into English in 1953 as *Female Sexuality*) is reminiscent of Lombroso in its constant appeals to an ideal of normal femininity. In 1924, her article, 'Considerations on the Anatomical Causes of Frigidity in Women', argues that while certain types of frigidity are due to psychic inhibition, and are therefore susceptible to cure by psychotherapy, others can be attributed to too great a distance between the clitoris and the opening of the vagina. Having come up with this anatomical theory, Marie Bonaparte was delighted to discover Dr Halban of Vienna, a surgeon who had developed an operation which consisted in moving the clitoris closer to the urethral passage. In the 1924 article, signed A.E. Narjani, Marie Bonaparte wrote that five women had been operated on, with positive results. Later, she was forced to admit that the operation was not always one hundred per cent successful.

In December of 1924, after a long illness (salpingitis, or inflammation of the Fallopian tubes), which struck immediately after her father's funeral, and an operation to remove an ovarian cyst, which kept her in bed for three months, Marie Bonaparte (who had virtually unlimited wealth, inherited from her mother's family, the Blancs, who owned the casino at Monte Carlo) imported the plastic surgeon Sir Harold Delf Gillies from London, whom she had met through King George V the previous summer. Gillies performed two operations: first, to 'correct' her breasts, and then, to retouch a scar at the base of her nose, a scar she'd had surgically adjusted twice before. At this time, Marie Bonaparte was forty-two years old and sexually very active, having had a series of passionate love affairs since her marriage to Prince George of Greece and Denmark, who was a closet homosexual, in love with his uncle, Prince Waldemar.

On February 21, 1925, Marie Bonaparte invited Drs René Laforgue and Otto Rank to dinner, to discuss psychoanalysis. She received them in bed, still recuperating from her operations. In April, at Marie Bonaparte's request, Laforgue wrote to Freud, inquiring if he would accept her as a patient for psychoanalysis. In May, she was taking a cure in the south of France for persistent pains in the lower abdomen, pains she and Laforgue believed to have a psychological origin. (These pains seem to have been associated with her chronic pelvic inflammatory disease.) In June, Marie Bonaparte wrote directly to Freud for the first time. In September 1925, in Vienna, she began her analysis with Freud.

They got on like a house on fire. Freud quickly acceded to her request for two hours of his time

[16] See: J. Deniker and L. Laloy, 'Les Races Exotiques à l'Exposition Universelle de 1889', parts 1 and 2, *L'Anthropologie* (1890), vol.1, p.257-294, p.513-546, which includes sixteen extraordinary photographs by Prince Roland Bonaparte.

[17] Celia Bertin, *Marie Bonaparte: A Life*, (New York, 1982), p.39.

[18] A.E. Narjani, 'Considérations sur les causes anatomiques de la frigidité chez la femme', *Bruxelles Médical*, April 27, 1924.

daily. He enjoyed the *'Prinzessin'*, and maliciously confided: 'Lou Andreas-Salomé is a mirror — she has neither your virility, nor your sincerity, nor your style'.[19] It was not long before Marie Bonaparte decided to become a psychoanalyst, and gradually she became close friends with Ruth Mack Brunswick (who later became a junkie) and Anna Freud. Marie Bonaparte showed Freud her breast, and discussed his personal finances with him. She gave him a chow, and thereafter the aged Freud became a fervent dog lover. The dogs functioned as a kind of extended family across Europe: puppies were exchanged, dogs were mated, and their deaths lamented. In 1936, Freud wrote to Marie Bonaparte of the 'affection without ambivalence... that feeling of an intimate affinity, of an undisputed solidarity', which he felt for his chow, Jo-fi.[20] And in 1938, together with Anna Freud, he translated Marie Bonaparte's book, *Topsy, Chow-Chow au Poil d'Or* — 'Topsy, the Chow with the Golden Hair'.[21]

In July 1926, in Vienna, (after six months of analysis with Freud), Marie Bonaparte had her first consultation with Dr Halban. In the spring of 1927, she had Halban sever her clitoris from its position and move it closer to the opening of her vagina. She always referred to this operation by the name 'Narjani'. The origins of this pseudonym are obscure. The operation, performed under local anaesthesia and in the presence of Ruth Mack Brunswick, took 22 minutes. Freud disapproved. It was 'the end of the honeymoon with analysis'.[22] In May Marie Bonaparte wrote to Freud that she was in despair over her stupidity. Freud, stern but forgiving, it seems, encouraged her to look after her seventeen year old daughter, Eugenie, who had been diagnosed as suffering from tuberculosis. Marie Bonaparte felt Freud was reproaching her for her narcissism. In June 1927, the very first issue of the *Revue Française de Psychanalyse*, financed by Marie Bonaparte, came out, and in 1928 she began to practise as an analyst, with Freud himself giving postal supervision.

Marie Bonaparte's conduct of psychoanalysis was from the beginning almost as unorthodox as that of her great enemy, Jacques-Marie Lacan. She would send her chauffeur in a limousine to pick up her patients, to drive them to her palatial home in Saint-Cloud for their sessions. In fine weather, the hour was spent in the garden, with Marie Bonaparte stretched out on a chaise-longue behind the couch. She always crocheted as she listened, indoors or out. In later years, whenever possible, she would take her patients with her, as guests, to her houses in St Tropez or Athens, thus inventing the psychoanalytic house party.

In April 1930, Marie Bonaparte visited Vienna, in order to consult Dr Halban again. The sensitivity in the original place from which the clitoris had been moved persisted. (During this period, Marie Bonaparte was involved in a long affair with Rudolph Loewenstein, who had been Lacan's analyst at one time, and also analysed her son, Peter.) Halban proposed further surgery on the clitoris, in combination with a total hysterectomy to finally eliminate her chronic salpingitis. Ruth Mack Brunswick was again present at the operation, which took place in May.

In February 1931, Marie Bonaparte had her clitoris operated on by Halban for the third and last time. Throughout this time, of course, Freud was suffering from cancer of the jaw, and undergoing regular operations. Her daughter's health was also very bad during this period, and Eugenie had to have an extremely painful operation on a tubercular cyst in her leg in May 1931.

From very early childhood, Marie Bonaparte was fascinated by murder. Servants' gossip vividly presented the probability that the impecunious and unfeeling Prince Roland, conspiring with his scheming mother, Princess Pierre, had, so to speak, hastened the end of the young heiress, Marie's mother. Marie Bonaparte's very first contribution to the nascent *Revue Francaise de Psychanalyse* was an essay on *'Le Cas de Madame Lefèbvre'*,[23] an upper middle class woman from the north of

[19] Celia Bertin, Op.cit., p.155.

[20] Letter from Sigmund Freud to Marie Bonaparte of December 6, 1936, No.288 in Ernest L. Freud (ed.), *Letters of Sigmund Freud*, (New York, 1960). I am indebted to Anne Friedberg for drawing my attention to the dogs.

[21] Marie Bonaparte, *Topsy, Chow-Chow au Poil d'Or* (Paris, 1937), Sigmund and Anna Freud's translation published in Amsterdam, 1939.

[22] Celia Bertin, Op.cit., p.170.

[23] Marie Bonaparte, 'Le Cas de Madame Lefèbvre', *Revue Francaise de Psychanalyse*, (1927), vol.I, p.149-198.

France, who had shot her pregnant daughter-in-law in cold blood, while out for a drive with the young couple. Marie Bonaparte's second psychoanalytic essay, published the same year, is entitled: *'Du Symbolisme des Trophées de Tête',* or 'On the Symbolism of Heads as Trophies'. The essay investigates the question, why does the cuckolded husband traditionally wear horns, when otherwise horns are a symbol of virility and power, in both animals and gods. She argues that the relation between castration and decapitation is always played out in terms of the Oedipal drama, and the ridiculous figure of the betrayed husband reconstructs this drama in fantasy, where the laughing spectator unconsciously identifies with the lover, the unfaithful wife stands in for the mother, and the cuckold represents the father. His totemic horns ironically invoke his paternal potency, while the childish wish to castrate (or murder) the father, to turn this threat against him, is sublimated in laughter and derision.[24]

Marie Bonaparte is perhaps most admired for her efficient arrangement of Freud's departure from Vienna in June 1938, after the German invasion of Austria in March of that year. She enlisted the help of the Greek diplomatic corps, and the King of Greece himself, in smuggling Freud's gold out of Austria.[25] On the 5th of June, Freud and his family spent twelve hours in Paris, at Marie Bonaparte's house at Rue Adolphe Yvon, sitting in the garden and resting on the long journey from Vienna to London. Freud had not set foot in his beloved Paris since 1889, the summer of the Universal Exposition celebrating the centenary of the Revolution. Marie Bonaparte was also personally responsible for saving Freud's letters to Fliess, a correspondence which Freud himself would have preferred to suppress.[26]

In *Female Sexuality* (1951), Marie Bonaparte wrote at length about the practice of clitoridectomy in Africa, and about the operation that she here called 'the Halban-Narjani operation',[27] in the last section of her book, 'Notes on Excision'. In this text, she once again presents her theories on frigidity in women. Total frigidity, she suggests, where both vagina and clitoris remain anaesthetic, is 'moral and psychogenic, and psychical causes [including psychoanalysis] may equally remove it'.[28] For this reason, she writes: 'The prognosis for total frigidity in women is generally favourable.'[29] Not so the cases of partial frigidity, in which the woman experiences clitoral pleasure, but no vaginal orgasm. Marie Bonaparte considers whether the cultural prohibition on infantile masturbation works in the same way as the practice of clitoridectomy, as an attempt to 'vaginalize' the woman, to internalize the erotogenic zone, and intensify vaginal sensitivity. She concludes that neither method succeeds in 'feminizing' or 'vaginalizing' the young girl, and sees such physical or psychical 'intimidation' as cruel and unproductive.[30]

Earlier in *Female Sexuality*, Marie Bonaparte writes specifically about Halban's operation, referring once again to five cases, two of which could not be followed up, two showed 'generally favourable, though not decisive results',[31] and one was unsuccessful. It is difficult to identify Marie Bonaparte herself among these five cases, although one cannot help suspecting the last. In this case, after the operation, the woman 'had only been fully satisfied twice in normal coitus, and then only while the cut, which became infected, remained unhealed, thus temporarily mobilizing the essential feminine masochism. Once the cut healed, she had to revert to the sole form of coitus which had so far satisfied her: the kneeling position on the man lying flat.'[32] Marie Bonaparte comments: 'This woman's masculinity complex was exceptionally strong.'[33]

[24] Marie Bonaparte, 'Du Symbolisme des trophées de tête', *Revue Francaise de Psychanalyse,* (1927), vol.I, p.677-732.

[25] See: Ernest Jones, *The Life and Work of Sigmund Freud,* (New York, 1953), vol.III, p.227.

[26] See 'peacock anecdote' below, Ernest Jones, Op.cit., vol.I, p.288.

[27] Marie Bonaparte, *Female Sexuality,* (London, 1953), p.202.

[28] Ibid., p.202.

[29] Ibid., p.202.

[30] Ibid., p.204.

[31] Ibid., p.151.

[32] Ibid., p.151.

[33] Ibid., p.151.

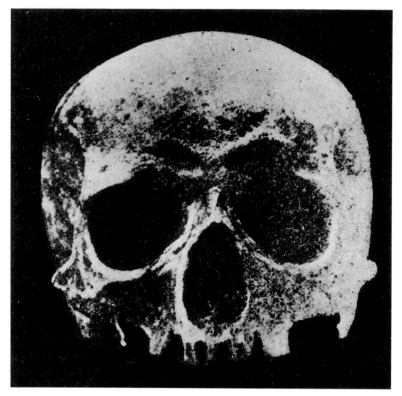

Skull of Charlotte Corday (Fig. 3)

In July 1793, Charlotte Corday travelled alone to Paris from Caen, in Normandy, in order to assassinate Marat. Passionately attached to the cause of the Girondins, she firmly believed the death of Marat would restore order and bring peace to France. She intended to kill Marat on the Champ de Mars on July 14th, at the Fête de la Liberté, the fourth anniversary of the storming of the Bastille. She later wrote that she had expected to be torn to pieces immediately by the people. She soon learned, however, that Marat was too ill either to take part in the festival or to attend the Convention. Corday was reduced to subterfuge in order to gain admittance to Marat's house.

On the 12th of July, Corday wrote her testament, a passionate justification of assassination, and pinned it, with her baptismal certificate and *laissez passer,* inside her dress. Very early the next morning, she put on a brown dress and a tall black hat, in the typical fashion of Normandy, and carrying her gloves, fan, and handbag containing watch, keys, and money, she left her cheap hotel to buy a kitchen knife. The heat was already intense.

At nine o'clock she took a cab to Marat's residence, No. 20, Rue des Cordeliers, where he lived in cramped quarters above the press of his journal *'L 'Ami du Peuple'.* The concierge asked Corday what she wanted, and she turned away without a word, walking quickly down the street. Corday returned at about half past eleven, managing to get past the concierge without being seen. She rang the bell, and Marat's partner, Simonne Evrard, and her sister, Catherine Evrard, together refused her entry. Marat was too ill to receive anyone.

Corday returned to the Hôtel de la Providence, and wrote Marat a letter, telling him she wanted to see him in order to give him information about the Girondist plots in Caen. She posted this, and then sat down to wait for a reply. In the late afternoon, she wrote a second letter, again appealing to be allowed a short interview. She ended this letter with the words, *'Il suffit que je sois bien Malheureuse pour avoir Droit à votre bienveillance.'* — 'My great unhappiness gives me

the right to your kindness.'[34] She posted this second letter, but Marat was dead before it was delivered.

Corday returned to the Rue des Cordèliers at about seven in the evening, hoping to arrive shortly after her second letter. She had spent the afternoon having her hair done; she sent for a hairdresser to come to the hotel, he curled and set her hair, and powdered it lightly. She also changed her outfit. Thinking of Judith of Bethulia, she surmised that Marat was more likely to grant her an audience if she was seductively dressed. She wore a loose spotted muslin dress with a fichu of delicate pink gauze. She tied green ribbons around her high black hat, and once again took a cab to Marat's house.

At the door, Corday argued, first with the concierge and then with Simonne Evrard, until Marat, in his bath, called out to his companion, who went in to him. He would see Charlotte Corday.

Marat was in a tiny room, between the passage and his bedchamber, that was lit by two windows onto the street. He was sitting in a shoe bath, naked, with an old dressing gown thrown across his shoulders. A slab of wood rested across the bath, to serve as a desk, and on this were placed paper, pen, and a bottle of ink tilted by a small bit of wood. His head was wrapped in a cloth soaked in vinegar.

He was near death, as a result of his illnesses, which were various; he suffered acutely from eczema, migraines, herpes, diabetes, arthritis, and neurasthenia. His gastric troubles required him to consume only liquids, and in order to sustain his furious writing practice, Marat drank a minimum of twenty cups of coffee a day. The sores and lesions that covered his body were a horrifying sight; people were often reluctant to sit next to him in the Convention. One expert described his disease as '*L 'affection squammeuse et vésiconte*,'[35] a sort of generalised scaly eczema. His body deteriorated quickly after his death, although this was partly due to the extreme July heat.

Admitted to his closet, Charlotte Corday talked to Marat briefly about the Girondists at Caen, her fan in one hand and her knife in the other, and then stabbed him, plunging the knife straight downwards into his naked breast. Marat cried out, 'A moi, chère amie, à moi!'[36] Charlotte Corday was shocked to see Simonne Evrard's distress. There was a tremendous amount of blood, and he died almost immediately. Simonne Evrard and the cook dragged Marat's body out of his bath and tried to put him into bed. Charlotte Corday ventured into the corridor, but the street porter drove her into the salon, where he hit her over the head with a chair. A dentist appeared, followed by a doctor and the commissioner of police for the '*section du Théâtre Français*'. At eight o'clock Corday's second letter arrived; Guellard the police commissioner carefully wrote on it: 'This letter was not delivered... it was rendered useless by the admission of the assassin at half-past seven, at which hour she committed her crime.'[37]

David's extraordinary painting, '*Marat Assassiné*'[38] shows the Friend of the People dead in his bath, holding in his left hand the letter dated 13 July 1793, with the words clearly legible: '*Il suffit que je sois bien Malheureuse pour avoir Droit à votre bienveillance.*' On the packing case next to the bath lies an *assignat*, or promissory note, with a covering letter from Marat, evidence of his generosity: 'Give this *assignat* to your mother'. The bloodstained knife lies on the floor; Marat's limp right arm hangs down, still grasping his quill pen. On the packing case itself, in Roman capitals, the text: '*À MARAT. DAVID. L' AN II*'. These various texts, in simultaneous juxtaposition within the painting, tell the whole story, David's version of the story. Marat's skin is flawless and very pale.[39]

[34] Joseph Shearing, *The Angel of Assassination*, (New York, 1935), p.201.
[35] Dr Cabanès, 'La "Lèpre" de Marat', in *Le Cabinet Secret de l'Histoire*, (Paris, 1905), p.164.
[36] Dr Cabanès, 'Le Coup de Charlotte Corday', in *Les Indiscretions de l'Histoire*, (Paris, 1905), p.119.
[37] Joseph Shearing, Op.cit., p.213.
[38] Jacques-Louis David (1748-1825), *Marat Assassiné* 1793, Brussels, Musées Royaux des Beaux-Arts de Belgique.
[39] Jean Starobinski, *1789: The Emblems of Reason* (Rome, 1973, trans. Barbara Bray, Cambridge, Mass., 1988), p.118-119.

Historians argue over Charlotte Corday's beauty, the colour of her hair, and even what she was wearing when she committed the murder. After carefully weighing the different accounts, it seems she brought three outfits to Paris with her: the brown dress (before the murder), the spotted muslin (during), and a white dress (after), this last the dress she wore to her trial. To these outfits must be added the red chemise, which she wore to the guillotine, traditional execution dress for murderers, arsonists, and poisoners. On the subject of her hair, it seems to have been 'chestnut', and the tradition that holds her to have been *'blonde cendrée'*, or ash-blond, was misled simply by the light powder that the hairdresser Person applied the afternoon of the murder. As for her beauty, it is generally agreed that her chin was very large, a classic sign of degeneracy in Lombroso's theory, though by 1889 the skull was missing its lower jaw, so he never knew this. The only objective account of Charlotte Corday's physical appearance comes from the *laissez passer*, issued at Caen for her trip to Paris. She is described as: '24 years old, height five feet one inch *(cinq pieds un pouce)*, hair and brow chestnut *(châtains)*, eyes grey, forehead high, nose long, mouth medium, chin round, cleft *(fourchu)*, face oval'.[40] Her height is another area of uncertainty; often described as tall and striking, perhaps *'un pouce'* means two to three inches. Or possibly her traditional Normande hat, with its tall conical crown, added to her stature.

Immediately after the murder, the revolutionary press depicted Corday as a monster: *'une femme brune, noire, grosse et froide'* — *'malpropre, sans grâce... la figure dure insolente, érysipèlateuse et sanguine'*.[41] To the Gironde, needless to say, she was indescribably beautiful, an angel. Ironically, Corday's murder of Marat was a bloody turning point in the Revolution; it was arguably the event that precipitated the Terror. In 1836 Marat's sister, Albertine, declared: 'Had my brother lived, they would never have killed Danton, or Camille Desmoulins'.[42] Michelet notes his belief that Marat would have 'saved' Danton, 'and then saved Robespierre too; from which it follows that there would have been no Thermidor, no sudden, murderous reaction'.[43]

On the 16th of July, the funeral of Marat took place. In charge of the design, David passionately wanted to display the corpse of Marat arranged in his bath exactly as in his painting. Unfortunately, the corpse was in such state of corruption that, despite the valiant efforts of embalmers, this was not possible. The body was placed in a sarcophagus of purple porphyry taken from the collection of antiquities at the Louvre; a huge tricolour drapery, soaked in alcohol, was wrapped around the body; the alcohol was renewed at regular intervals, in the hope of retarding the bodily decay which, as David noted, was already far advanced.

A right arm was carefully placed, the hand holding a pen, to hang over the edge of the sarcophagus. The eyes and mouth of Marat were wide open, impossible to close, and the tongue, protruding in his death agony, had been cut out. The vast funeral procession began at the club of the Cordeliers, and wound through the streets of Paris, the chariot on which Marat's body was displayed being pulled by twelve men, while young girls in white, carrying cypress boughs, walked alongside. Thousands followed the cortège. As evening fell, torches were lit. At midnight, the procession returned to the garden of the Cordeliers. Speeches, revolutionary hymns, and elegies continued until two in the morning. One unfortunate enthusiast rushed forward to kiss the hand that held the pen, and the arm came off. One of David's special effects, the arm did not belong to Marat. Finally Marat was buried beneath a granite pyramid (designed by Martin), although the removal of his remains to the Panthéon was already planned. The funeral became a saturnalia that went on all night.

In prison, Charlotte Corday passed the 16th of July writing a long letter to Charles Barbaroux, the Girondin activist at Caen. In this letter she gave a complete account of her trip from Caen

[40] Dr Cabanès, 'La Vraie Charlotte Corday — était-elle jolie?', in *Le Cabinet Secret de l'Histoire*, Paris, 1905), p.181.

[41] Joseph Shearing, Op.cit., p.230.

[42] Jules Michelet, *History of the French Revolution*, (trans. Keith Botsford, Pennsylvania, 1973), vol.VI, Book 12, 'Anarchic Rule of the Hebertists', p.169.

[43] Jules Michelet, Ibid.

to Paris, the days of uncertainty at the hotel, the murder, and the aftermath. Her tone is elated: 'A lively imagination, a sensitive heart, promised me a stormy life; let those who regret me consider this and let them rejoice to think of me in the Elysian Fields with some other friends.'[44] On the 15th she had asked for a painter to come to the prison and paint her portrait: *Je vous en prie de m'envoyer un peintre en miniature.*[45] Corday wrote to Barbaroux that she always intended to remain anonymous, expecting to be torn to pieces immediately after the murder. Yet she pinned her identity papers and her manifesto inside the bosom of her dress, and in prison she both requested a portrait painter and had a hat made — *'faite à Paris selon la mode du temps'*[46] — a white bonnet which she wore to the scaffold.

At the trial, on the 17th, an ex-pupil of David and captain of the National Guard, Hauer, made a drawing of Charlotte Corday. She moved her head to afford him a better view. When the guilty verdict came through at mid-day, Hauer accompanied Corday to her cell, in order to improve his drawing. As he worked, she made suggestions and posed for him, placing her hands folded on her breast.

The executioner Sanson appeared at about three o'clock. In his memoirs he recalled that when Corday saw him come in, holding a pair of scissors in one hand and the *chemise rouge* in the other, she inadvertently exclaimed, *'Quoi, déjà!'* — 'What, already!'[47] However, she soon regained her equilibrium. As Sanson was cutting her hair, she took the scissors from him and cut off a long lock to give to Hauer.

Usually worn by men, the red chemise hung low on her breast. Corday refused the chair offered by Sanson, preferring to stand in the tumbril, facing the insults and admiration of the crowd. Thousands turned out to see her go to the scaffold, in the Place de la Revolution (now the Place de la Concorde) It poured with rain for three quarters of an hour, as the cart moved slowly through the thronged streets, and the *chemise rouge*, soaked through, outlined her body, moulding her breasts. She paled slightly at the sight of the scaffold, but recovered by the time she got to the top of the steps. Sanson writes that he attempted to place himself in such a position as to block her view of the guillotine. Corday made a point of looking, commenting: 'In my position, one is naturally curious.'[48]

She tried to address the people, but was given no time; her fichu was torn off her neck, and in a moment, it seemed, her head rolled on the ground. Immediately one of Sanson's assistants, a follower of Marat called Legros, ran his knife up the severed neck and held the head high to show it to the crowd, whereupon he gave it a slap, or possibly two or three slaps. The face was seen to blush — not only the cheek was slapped, but both cheeks, exactly as if she were still able to feel emotion. The spectators were appalled; Michelet writes: 'a tremor of horror ran through the murmuring crowd'.[49]

Much discussion ensued on the likelihood of sensation remaining after decapitation. Scientists entered into elaborate disputations on the *force vitale*, and on whether the head blushed from shame, grief, or indignation. Sanson wrote a letter to the newspaper, condemning the action; he considered it one of the most shameful moments of his career. Legros himself was thrown into jail.[50]

Immediately after the execution, an autopsy was carried out on the body, principally to determine Charlotte Corday's virginity. At the trial she'd been asked how many children she had, and the revolutionary press claimed she was four months pregnant. Perhaps the heroic and virginal

[44] Joseph Shearing, Op.cit., p.236-7.
[45] Ibid., p.234.
[46] Dr Cabanès, Op.cit., 'La Vraie Charlotte Corday — était-elle jolie?', p.188.
[47] Dr Cabanès, 'La Vraie Charlotte Corday — Le Soufflet de Charlotte Corday', *Le Cabinet Secret de l'Histoire*, (Paris, 1905), p.198.
[48] Christopher Hibbert, *The Days of the French Revolution*, (New York, 1981), p.309.
[49] Jules Michelet, Op.cit., Book 12, 'The Death of Charlotte Corday', P.146. (l.c.p.)
[50] Jules Michelet, Ibid., p.146.

figure of Jeanne d'Arc was behind this compulsion to prove Corday promiscuous. In any case, David himself, as a member of the National Convention, attended the autopsy, believing or hoping that 'traces of libertinage' would be found. To his chagrin, her virginity was confirmed. There exists a vivid description of a drawing of this scene:

> The body lies outstretched on a board, supported by two trestles. The head is placed near the trunk; the arms hang down to the ground; the cadaver is still dressed in a white robe, the upper part of which is bloody. One person, holding a torch in one hand and an instrument (some kind of speculum?) in the other, seems to be stripping Charlotte of her clothing. Four others are bending forward, examining the body attentively. At the head we find two individuals, one of whom wears the tricolour belt; the other extends his hands as if to say: "Here is the body, look."[52]

Historians generally agree that Charlotte Corday's body was buried in Ditch No.5 in the cemetery at the Madeleine, Rue d'Anjou-Saint-Honoré, between Ditch No.4, which held the corpse of Louis XVI, and No.6, which would soon receive the bodies of Phillipe Egalité and Marie Antoinette. Chateaubriand was responsible for exhuming the royal remains in 1815, and left a vivid account, in his *Mémoires d'outre-tombe,* of how he recognised the skull of Marie Antoinette, from his recollection of the smile she gave him on one occasion at Versailles in early July 1789 just before the fall of the Bastille:

> When she smiled, Marie Antoinette drew the shape of her mouth so well that the memory of that smile (frightful thought!) made it possible for me to recognise the jaw-bone of this daughter of kings, when the head of the unfortunate was uncovered in the exhumations of 1815.[53]

It remains a mystery, however, precisely how the skull of Charlotte Corday came to be in the collection of Prince Roland Bonaparte. Dr. Cabanès, celebrated collector of historical gossip and author of such valuable works as *Le Cabinet Secret de l'Histoire* (1905), *Les Indiscretions de l'Histoire* (1903), and *Les Morts mystèrieuses de l'Histoire* (1901), carried out extensive and thorough research on the provenance of this skull. He learned from Prince Roland that he had acquired it from M. George Duruy, 'who said he would not be sorry to get rid of this anatomical item because it terrified Mme. Duruy'.[54] Duruy himself told Cabanès he'd discovered the skull at his aunt's, Mme. Rousselin de Saint-Albin; a wardrobe door was standing slightly open, and Duruy spotted the skull sitting on a shelf inside. Mme. de Saint-Albin told him it had belonged to her late husband, who was himself convinced it was the skull of Charlotte Corday. Indeed, Rousselin de Saint-Albin had gone so far as to write 'a sort of philosophical dialogue' between himself and the skull, in which they discuss her motives for the crime.[55] Saint-Albin claimed to have bought the skull from an antiquary on the Quai des Grands-Augustins, who had himself bought it in a sale. Cabanès speculates on the likelihood of the sale in question being that of the 'célèbre amateur', Denon, which took place in 1826, but notes that the catalogue of this sale does not mention a skull.[56]

Duruy himself believed that Saint-Albin was in a position to take possession of the skull immediately after the execution, since Saint-Albin was Danton's secretary, and therefore could have obtained the necessary authorisation. Cabanès returns to the evidence of the anthropologists who examined the skull at the Universal Exposition of 1889, Bénédikt, Lombroso, and Topinard, who agreed that the skull 'had been neither buried in the earth, nor exposed to the air'.[57] Was the skull dug up immediately, or was it perhaps sold by the executioner, Sanson? Cabanès suggests

[51] Dr Cabanès, 'La Vraie Charlotte Corday — L'autopsie de Charlotte Corday', *Le Cabinet Secret de l'Histoire,* (Paris, 1905), p.211.

[52] Ibid., p.209.

[53] Francois-René [Vicomte] de Chateaubriand, *Mémoires d'outre-tombe,* (Paris, 1964), vol.2. I am indebted to M. Patrick Bauchau for drawing my attention to this reference.

[54] Dr Cabanès, Op.cit., p.218.

[55] Ibid., p.219.

[56] Ibid., p.218.

[57] Ibid., p.220.

that the story that is always denied most vehemently is likely to be the true account: that after the autopsy, *'la tête aurait été préparée par quelque médecin et conservée comme pièce curieuse'* — 'the head was *treated* by some doctor and preserved as a curiosity'.[58]

Finally, Cabanès includes, as an appendix to his investigation, a long letter from M. Lenotre, 'the very knowledgable historian of *'Paris révolutionnaire'*,[59] to his friend G. Montorgueil, which was written in the full awareness that the letter would be passed on to Dr. Cabanès. In this letter, Lenotre ventures his opinion that the skull is authentic. He argues that there was a thriving trade in body parts and hair of the victims of the guillotine, and points to the later wealth of the Sanson family as evidence that Sanson was 'in a good position to render certain services, to make deals, to traffic a little in the guillotine'.[60] Lenotre goes on to recount an anecdote of the period:

> If (Sanson) didn't sell heads, who did? For there's no question they were sold! One evening in 1793, a woman fainted in the Rue Saint-Florentin; she fell; a package she was carrying in her apron rolled into the gutter: it was a head, freshly decapitated... . She was on her way from the cemetery at the Madeleine, where a grave-digger had supplied her with this horrible debris.[61]

Lenotre's most striking contribution to the discussion, however, is a description of a dinner party chez Rousselin de Saint-Albin:

> One evening, during the reign of Louis Philippe, Saint-Albin invited to dinner a group of friends who were curious about the history of the Revolution. He promised them a sensational surprise. At dessert, a large glass jar was brought in, and removed from its linen case. This was the surprise, and how sensational it was, you can judge, for the glass jar contained the head of Charlotte Corday. Not the skull merely, you understand, but the head, conserved in alcohol, with her half-closed eyes, her flesh, her hair... . The head had been in this condition since 1793; lately Saint-Albin had decided to have it *prepared* — excuse these macabre details — and wanted, before this operation, to allow his friends the spectacle of this thrilling relic.[62]

Once a head, preserved in alcohol; then a skull, to hold in one's hands, to measure. Now all that remains of Charlotte Corday, the last vestiges of the 'thrilling relic', are three photographs of the skull itself. And yet, how evocative these photographs seem, how poetic, these emblems of castration, perhaps, *memento mori* of the Revolution, these shadowy traces of secret exhumation.

> He (Freud) was indignant about the story of the sale (of the Fliess correspondence to Marie Bonaparte) and characteristically gave his advice in the form of a Jewish anecdote. It was the one about how to cook a peacock. "You first bury it in the earth for a week and then dig it up again." "And then?" "Then you throw it away!"[63]

58 Ibid,. p.221.
59 Ibid., p.222.
60 Ibid., p.223.
61 Ibid., p.224. For traffic in skulls, see also: Folke Henschen, *The Human Skull, A Cultural History*, (trans. S. Thomas, London, 1966).
62 Dr Cabanès, Op.cit., p.222-3.
63 Ernest Jones, Op.cit., vol.I, p.288.

FIRE AND ICE

Peter Wollen

The aesthetic discussion of photography is dominated by the concept of time. Photographs appear as devices for stopping time and preserving fragments of the past, like flies in amber. Nowhere, of course, is this trend more evident than when still photography is compared with film. The natural, familiar metaphor is that photography is like a point, film like a line. Zeno's paradox: the illusion of movement.

The lover of photography is fascinated both by the instant and by the past. The moment captured in the image is of near-zero duration and located in an ever-receding 'then'. At the same time, the spectator's 'now', the moment of looking at the image, has no fixed duration. It can be extended as long as fascination lasts and endlessly reiterated as long as curiosity returns. This contrasts sharply with film, where the sequence of images is presented to the spectator with a predetermined duration and, in general, is only available at a fixed programme time.

It is this difference in the time-base of the two forms that explains, for example, Roland Barthes' antipathy towards the cinema and absorption in the still photograph. Barthes' aesthetic is governed by a prejudice against linear time and especially against narrative, the privileged form of linear time as he saw it, which he regarded with typically high-modernist scorn and disdain. His major work on literature, *S/Z*, is a prolonged deceleration and freeze-framing, so to speak, of Balzac's (very) short story, marked throughout by a bias against the hermeneutic and proaeretic codes (the two constituent codes of narrative) which function in 'irreversible time'.

When Barthes wrote about film he wrote about film stills; when he wrote about theatre he preferred the idea of *tableaux vivants* to that of dramatic development. Photography appeared as a spatial rather than temporal art, vertical rather than horizontal (simultaneity of features rather than consecutiveness) and one which allowed the spectator time to veer away on a train of thought, circle back, traverse and criss-cross the image. Time, for Barthes, should be the prerogative of the reader/spectator: a free re-writing time rather than an imposed reading time.

I don't want, here and now, to launch into a defence of narrative; that can keep for another day. But I do want to suggest that the relationship of photography to time is more complex than is usually allowed. Especially, it is impossible to extract our concept of time completely from the grasp of narrative. This is all the more true when we discuss photography as a form of art rather than as a scientific or instructional instrument.

First, I am going to talk about 'aspect' rather than 'tense'. Linguists do not completely agree about the definition of 'aspect'. But we can say that while 'tense' locates an event in time in relation to the present moment of speech, 'aspect' represents its internal temporal structure. Thus, some verbs, like 'know' are 'stative' — they represent 'states', whereas others like 'run' represent dynamic situations that involve change over time — so we can say 'he was running', but not 'he was knowing'. 'Situations' can be subdivided into those that involve single, complete 'events' and those that involve 'processes', with continuous change or a series of changes, and so on. The verbs which represent 'events' and 'processes' will have different relations to 'aspectual' verb forms such as the 'imperfect', the 'perfect' (both past tense), the 'progressive', etc. (Here I must acknowledge my dependence on and debt to Bernard Comrie's book on 'Aspect', the standard work on the subject). Aspect, on one level, is concerned with duration but this, in itself, is inadequate to explain its functioning. We need semantic categories which distinguish different types of situation, in relation to change (or potential for change) and perspective as well as duration. Comrie distinguishes between states, processes and events. Events themselves can be broken down between durative and punctual events. Alongside these categories aspect also involves the concepts of the iterative, the habitual and the characteristic. It is the interlocking of these underlying semantic categories which determines the various aspectual forms taken by verbs in different languages *(grosso modo)*.

It is useful to approach photography in the light of these categories. Is the signified of a photographic image to be seen as a state, a process or an event? That is to say, is it stable, unchanging, or, if it is a changing, dynamic situation, is it seen from outside as conceptually complete, or from inside, as ongoing? (In terms of aspect, stative or perfective/imperfective non-stative?) The fact that images may themselves appear as punctual, virtually without duration, does not mean

that the situations that they represent lack any quality of duration or other qualities related to time.

Some light is thrown on these questions by the verb-forms used in captions. (A word of warning: English, unlike French, distinguishes between perfective and imperfective forms, progressive and non-progressive, in the present tense as well as the past. The observations which follow are based on English-language captions). News photographs tend to be captioned with the non-progressive present, in this case, a narrative present, since the reference is to past time. Art photographs are usually captioned with noun-phrases, lacking verb-forms altogether. So also are documentary photographs, though here we do find some use of the progressive present. This imperfective form is used more than usual, for example, in Susan Meiselas' book of photographs, *Nicaragua*. Finally, the imperfective is used throughout in the captions of Muybridge's series photographs, in participle form.

Evidently these choices of verb-form correspond to different intuitions about the subjects or signifieds of the various types of photograph. News photographs are perceived as signifying events. Art photographs and most documentary photographs signify states. Some documentary photographs and Muybridge's series in particular are seen as signifying processes. From what we know about minimal narratives, we might say that an ideal minimal story-form might consist of a documentary photograph, then a news photograph, then an art photograph (process, event, state).

In fact, the classic early film minimal narrative, Lumière's *'L'Arroseur Arrosé'*, does follow this pattern: a man is watering the garden (process), a child comes and stamps on the hose (event), the man is soaked and the garden empty (state). What this implies of course is that the semantic structure of still and moving images may be the same or, at least, similar, in which case it would not be movement but sequencing (editing, découpage) which made the main difference by determining duration differently.

Still photographs, then, cannot be seen as narratives in themselves, but as elements of narrative. Different types of still photograph correspond to different types of narrative element. If this conjecture is right, then a documentary photograph would imply the question: 'Is anything going to happen to end or to interrupt this?' A news photograph would imply: 'What was it like just before and what's the result going to be?' An art photograph would imply: 'How did it come to be like this or has it always been the same?' Thus different genres of photography imply different perspectives within durative situations and sequences of situations.

While I was thinking about photography and film, prior to writing, I began playing with the idea that film is like fire, photography is like ice. Film is all light and shadow, incessant motion, transience, flicker, a source of Bachelardian reverie like the flames in the grate. Photography is motionless and frozen, it has the cryogenic power to preserve objects through time without decay. Fire will melt ice, but then the melted ice will put out the fire (like in 'Superman III'). Playful, indeed futile, metaphors, yet like all such games anchored in something real.

The time of photographs themselves is one of stasis. They endure. Hence there is a fit between the photographic image which signifies a state and its own signified, whereas we sense something paradoxical about the photograph which signifies an event, like a frozen tongue of fire. In a film, on the contrary, it is the still image (Warhol, Straub-Huillet) which seems paradoxical in the opposite sense: the moving picture of the motionless subject.

Hence the integral relationship between the still photograph and the pose. The subject freezes for the instantaneous exposure to produce a frozen image, state results in state. In *La Chambre Claire*, Barthes keeps returning to the mental image of death which shadows the photographs that fascinate him. In fact these particular photographs all show posed subjects. When he treats unposed photographs (Wessing's photograph of Nicaragua, Klein's of May Day in Moscow) Barthes sees not death, even when they show death, but tableaux of history, 'historemes' (to coin a word on the model of his own 'biographemes'). Images, in fact, submitted to the Law.

I can't help wondering whether Barthes ever saw James Van Der Zee's *Harlem Book of the Dead*, with its photographs of the dead posed for the camera in funeral parlours: a triple registration

of stasis — body, pose, image. The strange thing about these photographs is that, at first glance, there is an eerie similarity between mourners and corpses, each as formal and immobile as the other. Indeed, the interviewers whose questioning of Van Der Zee makes up the written text of the book, ask him why the eyes of the bodies aren't opened, since this would make them look more life-like, virtually indistinguishable from the mourners even to the smallest detail.

This view of death, of course, stresses death as a state rather than an event. Yet we know from news photographs that death can be photographed as an event: the Capa photograph of the Spanish Civil War soldier is the *locus classicus*, taken as he is felled. There is a sense, though, in which Barthes was right. This photograph has become a 'historeme', a 'pregnant moment' after Diderot or Greuze, or like the habitual narrative present in Russian, where, according to Comrie, 'a recurrent sequence of events is narrated as if it were a single sequence, i.e. one instance stands for the whole pattern'. In my book of Capa photographs, it is captioned simply 'Spain, 1936'.

The fate of Capa's photograph focusses attention on another important aspect of the way images function in time: their currency, their circulation and re-cycling. From the moment they are published, images are contextualised and, frequently, if they become famous, they go through a whole history of re-publication and re-contextualisation. Far more is involved than the simple doubling of the encounter of photographer with object and spectator with image. There is a very pertinent example of this in the case of Capa's photograph. It is clearly the model for the pivotal image of death in Chris Marker's film photo-roman *'La Jetée'* — the same toppling body with outstretched arm.

Marker's film is interesting for a lot of reasons. First of all, it is the examplar of a fascinating combination of film and still: the film made entirely of stills. (In just one imagé there is an eye-movement, the converse of a freeze frame in a moving picture). The effect is to demonstrate that movement is not a necessary feature of film; in fact, the impression of movement can be created by the jump-cutting of still images. Moreover, *'La Jetée'* shows that still photographs, strung together in a chain, can carry a narrative as efficiently as moving pictures, given a shared dependence on a sound-track.

It is not only a question of narrative, however, but also of fiction. The still photographs carry a fictional diegetic time, set in the future and in the present as past-of-the-future, as well as an inbetween near-future from which vantage-point the story is told. Clearly there is no intrinsic 'tense' of the still image, any 'past' in contrast with a filmic 'present', as has often been averred. Still photography, like film (and like some languages), lacks any structure of tense, though it can order and demarcate time.

Aspect, however, is still with us. In the 'past' of memories to which the hero returns (through an experiment in time-travel) the images are all imperfective, moments within ongoing states or processes seen as they occur. But the object of the time-travel is to recover one fixated memory-image, which, it turns out at the climax of the film, is that of the hero's own death. This image, the one based on Capa's 'Spain, 1936', is perfective; it is seen from the outside as a complete action, delimited in time with a beginning and an end. Although *'La Jetée'* uses a whole sequence of photographs, the single Capa image in itself carries the condensed implication of a whole action, starting, happening and finishing at one virtual point in time: a 'punctual' situation, in Comrie's terms. And, at this very point, the subject is split into an observer of himself, in accordance with the aspectual change of perspective.

My own fascination with pictorial narrative is not a recalcitrant fascination, like that of Barthes. Unlike him, I am not always longing for a way of bringing the flow to a stop. It is more a fascination with the way in which the spectator is thrown in and out of the narrative, fixed and unfixed. Traditionally, this is explained in terms of identification, distanciation, and other dramatic devices. Perhaps it is also connected with aspect, a dimension of the semantics of time common to both still and moving picture and used in both to place the spectator, within or without a narrative.

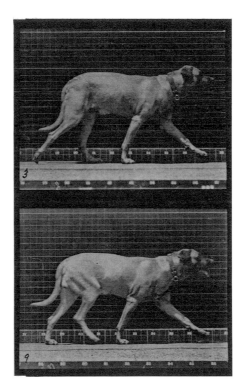

"Smith" trotting
detail, Plate 706
Eadweard Muybridge, **Animal Locomotion** 1887

Notes on Contributors

Anita Phillips was born in Britain. After working for some years as a journalist, she studied for an MA in Creative Writing at the University of Lancaster, during which she wrote her first novel, **The Virtues, the Vices and All the Passions,** an excerpt of which is published here. She has recently completed a second novel **Blameless.** She lives in London and works as a freelance sub-editor.

Francette Pacteau was born in France and studied at the Université de Grenoble and the Polytechnic of Central London. She is currently a research fellow in art history at the University of California, Santa Cruz and is completing her doctoral dissertation on the concept of feminine beauty for the University of Kent, of which 'Beautiful Fragments' is a part. Her article, 'The Impossible Referent: representations of the androgyne' appeared in **Formations of Fantasy** (1986).

John X Berger was born in Massachusetts and studied at Dartmouth College, the University of Edinburgh and Newcastle upon Tyne Polytechnic. He is Senior Lecturer in Photographic Studies at Derbyshire College of Higher Education. His writing has appeared occasionally in **Ten-8** and **Undercut.** In 1984 he edited Helmut Gernsheim's **Incunabula of British Photographic Literature**, also published in association with Derbyshire College. His work on the French Revolution, **Eighty-Nine**, will be exhibited later this year at the Richard Demarco Gallery, Edinburgh.

Karen Knorr was born in Germany and studied at the Polytechnic of Central London. Her photographic work has been exhibited internationally and is in many public collections, including the Arts Council of Great Britain, the Victoria and Albert Museum, and the Musée d'Art Moderne, Paris. Her publications include **Furor, Formations, Parachute,** and **Camera Austria.** She is presently preparing a monograph of her work to be published by Thames and Hudson. She is an Associate Lecturer at London College of Printing and lives in London. **Connoisseurs** appears by courtesy of Samia Saouma Gallery, Paris, and Salama-Caro, London.

Leslie Dick is an American writer who has lived in London since 1965. Her first novel, **Without Falling,** was published in London by Serpent's Tail in 1987 and in the United States by City Lights in 1988. Her story 'Envy', was published in **The Seven Deadly Sins** (ed. Alison Fell) by Serpent's Tail in 1988. She also writes occasionally about painting, literature, and performance art.

Marie Yates was born in England and studied at Hornsey College of Art, the Royal College of Art and Goldsmith's College. Her work has been included in numerous exhibitions, including **Time, Words and the Camera** (British Council 1976); **ISSUE: Social Strategies by Women Artists** (Institute of Contemporary Arts 1980); **Sense and Sensibility** (Midland Group Nottingham 1982); **Beyond the Purloined Image** (Riverside Studios 1983); and, **Difference** (The New Museum of Contemporary Art, New York 1984). Her work has appeared in **Art and Artists, Camerawork, Formations, Block, Aspects, Circa** and **Ten-8.** She is an Associate Lecturer at London College of Printing and lives in London.

Olivier Richon was born in Switzerland and studied at the Polytechnic of Central London. His work has been exhibited internationally and is included in the collections of the Arts Council of Great Britain, the Victoria and Albert Museum and the Brooklyn Museum, New York. His MPhil dissertation, 'Exoticism and Representation', was completed in 1987. Publications of his work include **Block, Screen, Parachute** and **Camera Austria.** He is an Associate Lecturer at Derbyshire College of Higher Education and lives in London. **Imprese** appears by courtesy of Jack Shainman Gallery, New York.

Peter Wollen was born in England and is a film-maker and the author of **Signs and Meaning in the Cinema** (1968). He has taught film theory at many institutions in Europe and the United States. His film, **Friendship's Death**, was completed in 1987. A collection of his articles was published as **Readings and Writings, Semiotic Counter Strategies** by Verso in 1982. He has written

frequently about photography. He is currently teaching at the University of California, Los Angeles, and is completing a new book, to be published by Verso in London and by the University of Indiana Press in the United States.

Victor Burgin was born in England and studied at the Royal College of Art and Yale University. He is now Professor of Art History at the University of California, Santa Cruz. His work has been exhibited in the Tate Gallery and the Victoria and Albert Museum, London; the Centre Georges Pompidou, Paris; and the Guggenheim Museum and the Museum of Modern Art, New York. His critical and theoretical writings have appeared in **Artforum, Screen, Twentieth Century Studies, New Formations, Architectural Design,** and **AA Files.** Burgin's books include: **Work and Commentary** (1973); **Thinking Photography** (ed., 1982 & 1986); and, **The End of Art Theory: Criticism and Post-Modernity** (1986).

Yve Lomax was born in England and studied at St Martin's School of Art and the Royal College of Art. Her photographic work has been exhibited widely and regularly, including **Three Perspectives on Photography** (Hayward Gallery 1979); **Sense and Sensibility** (Midland Group Nottingham 1982); **Beyond the Purloined Image** (Riverside Studios 1983); **Difference** (The New Museum of Contemporary Arts, New York 1984); **Re-Visions** (Cambridge Darkroom 1985); **Questioning Europe** (Rotterdam 1988); and, **Light of Touch** (Impressions Gallery, York 1988). Her self-published books include: **Recto/Verso** (1978), **Doubled-Edged Scenes** (1985) and **Future Politics/The Line in the Middle** (with Susan Trangmar, 1986). She is a part-time lecturer and lives in London.

Acknowledgements
The Editors would like to thank the Governors of Derbyshire College of Higher Education for their continuing commitment to, and support for activity in the field of publishing. Our thanks go also to: Camerawork, for its commitment to the project; the Berne Natural History Museum and the Musée de l'Elysée, Switzerland, for help in the realisation of **Imprese**; Susan Trangmar, for picture research; the contributors, who made this book possible; and, Dewi Lewis, for his patient ministrations throughout.
 The cover shows a detail of the portrait of Erasmus Darwin by Joseph Wright of Derby, courtesy of Derby Art Gallery, photo by Olivier Richon.
 Material for reproduction has been kindly provided also by the British Library, the Bridgeman Art Library, the National Library of Scotland and the Victoria and Albert Museum.